Identity Theft

**How to Protect
Your Name,
Your Credit and
Your Vital Information
...and What to Do
When Someone Hijacks
Any of These**

SILVER LAKE PUBLISHING
LOS ANGELES, CALIFORNIA

Identity Theft

How to Protect Your Name, Your Credit and Your Vital Information...and What to Do When Someone Hijacks Any of These

First edition, 2004
Copyright © 2004 by Silver Lake Publishing

Silver Lake Publishing
3501 W. Sunset Blvd.
Los Angeles, California 90026

For a list of other publications or for more information from Silver Lake Publishing, please call 1.888.638.3091. Outside the United States and in Alaska and Hawaii, please call 1.323.663.3082. Find our Web site at **www.silverlakepub.com**.

The Silver Lake Editors
Identity Theft
Includes index.
Pages: 264

ISBN: 1-56343-777-5
Printed in the United States of America.

 APR – – 2004

ACKNOWLEDGMENTS

The Silver Lake Editors who have contributed to this book are Kristin Loberg, Steven Son, Megan Thorpe and James Walsh.

This is the 12th title in Silver Lake Publishing's series of books dealing with risk and insurance issues. Throughout this book, we refer to insurance policy forms and legal decisions from the United States—but the discussion about risk and insurance can apply beyond the jurisdiction of the courts cited.

Most importantly: Identity theft is a phenomenon that's still developing. The legal precedents and insurance forms involved are in relatively early stages. Expect both to change as ID theft becomes a more familiar topic to judges and actuaries.

> This book is designed to give consumers a basic understanding of ID theft and its legal and financial effects. However, if you've been the victim of ID theft, consult with law enforcement agencies or an attorney in your area before taking any legal action.

The Silver Lake Editors welcome any feedback. Please call us at 1.888.663.3091 during regular business hours, Pacific time. Or, if you prefer, you can fax us at 1.323.663.3084. Finally, you can e-mail us at TheEditors@silverlakepub.com.

James Walsh, Publisher
Los Angeles, California

TABLE OF CONTENTS

WHY ID THEFT HAS
BECOME SUCH A
PROBLEM

Imagine getting a knock at your door one evening while you're having dinner with your family. When you open the door, two federal agents and a local cop stand on your doorstep **ready to arrest you**. The problem? You're accused of cocaine possession, distribution and money laundering. The Miranda begins.

The police have the wrong person. You've never even seen cocaine in your life. But it's going to take hours...maybe days...to straighten everything out. In the meantime, the Feds have banking records with your name and Social Security number on them that say you've been a drug dealer and money launderer for several years. You're handcuffed and shoved into the backseat of a policecar while your kids cry on the front lawn. And—despite your alleged drug wealth— you can't post bail to get out that night.

> Identity theft has become the fastest-growing crime; over 40 percent of all consumer complaints in the U.S. involve identity theft. ID theft will cost U.S.

consumers and their banks or credit card companies more than $1.4 billion in 2004. By 2006, losses could reach $3.68 billion.

Being dragged off to jail in front of your family may not be the worst that could happen. There you are—in jail for three days while you prove that the person committing all the **crime in your name** isn't you. But, once you get out of jail you still **live in fear** of getting arrested again and again.

Meanwhile, your imposter continues to use your identity to commit crimes and no one seems to be helping you find this crook and prosecute him. When you try to correct your criminal record, you run into several stumbling blocks. So, you contemplate a name change.

You'd think it would be easy to eliminate a record that clearly doesn't reflect you. You'd think it would be easy to convince the police, a judge, a government agency or similar authority that you're not a thief, crook, debtor, felon and conman.

But it's not so easy. It becomes your word against a database. To people who work with the database, you're a criminal—guilty until proven innocent.

A REAL LIFE EXAMPLE

Another scenario: A man quits his job in the hopes of finding a more rewarding career, only to learn that he can't get another job because his cousin had been arrested years earlier and had used his name in the arrest.

Terrance Summers worked as a Baltimore corrections officer for 17 years, then tried to start a new career. But he didn't get far. As soon as he applied for new jobs, he discovered that he had a criminal record; prospective employers found several drug felonies on his record. What had happened? His cousin Earl Anthony Thomas had given his name in 1987 when arrested on felony drug charges. This put Summers's name on the record, above his cousin's fingerprints.

> When Summers turned to Baltimore's district attorney's office, he learned the hard truth: Once a person's name is entered into a criminal justice database, it's not easy to get it purged. And, once someone's name is attached to a set of fingerprints—as Summers's name was linked to his cousin's—it's very difficult to change.

For Summers, the experience caused a **financial crisis**. Unable to secure a job and an income, he lost his fiancée (who left him due to the financial pressures), burned through his retirement money and lost his capacity to make ends meet for his 10-year-old daughter. Getting justice was going to be tough. His cousin, the man responsible for the trouble, had died in 1994.

> Some victims of ID theft find that their names have been misused after police stop them for a traffic violation and discover that there is a warrant for their arrest. There are also times when an innocent person receives a summons to appear in court to answer for a criminal act.

When cases like this reach the Baltimore D.A.'s office, the prosecutors investigate the stories and usually start with a fingerprint search. If a mistaken identity claim checks out, the prosecutor writes a letter stating that the victim has not been convicted of the charges on his record. That is all the office has the power to do. But for people like Summers, that's not always enough to convince prospective employers who find criminal charges during background checks.

> There's nothing new about criminals using aliases to evade the law. But the sudden increase in identity theft and the availability of stolen digital dossiers on innocent victims makes it too easy for criminals to get arrested and booked under a fake—possibly your—name. Once police have booked a suspect under your name, you could be plagued for life.

Identity theft is not just about getting falsely accused of crime or living with serious marks on your criminal record (now that you have one!). ID theft covers a **wide range of issues and crimes**. It goes from the trivial to the outrageous. From jail houses to coffee houses.

Most people don't think or worry about ID theft until they've become a victim. By then, it's often too late to prevent the situation from worsening before it gets better. A typical victim spends an average of $808 and 175 **hours over almost two years** cleaning up after an ID theft incident.

WHAT IS IDENTITY THEFT?

ID theft happens when someone **steals a piece of personal information** about you and uses it to commit a fraud in your name. The thief might steal your Social Security number, name, date of birth, credit card information, bank account numbers, mother's maiden name, etc., and use these things to:

- Open up new accounts;
- Change the mailing address on your current credit cards;
- Rent apartments;
- Establish services for utility companies;
- Write fraudulent checks;
- Steal and transfer money from a bank account;
- File bankruptcy;
- Obtain employment;
- Establish a new identity; and/or
- Apply for a mortgage, car loan or cell phone.

Once someone assumes your identity to get credit in your name and steal from businesses, you probably won't realize it happened until months later. Federal law limits a consumer's liability for credit card fraud to $50 per account. Visa and MasterCard have adopted zero-liability policies, but the real problem remains in the **clean-up of your credit report**.

According to a survey conducted by Privacy Rights Clearing and the California Public Interest Research Group, victims spend from $30 to $2,000 on costs related to identity theft, not including lawyer fees. The average loss: $808. (Interestingly, the FTC reported in December 2001 that 16 percent of all identity theft victims reported a loss of more than $10,000.)

And don't think that ID theft is only a hassle for adults. About 2 percent of identity thefts involve a child's Social Security number. Parents should check their **children's credit history** reports as they would their own for signs of theft. If your child receives mail, like unsolicited credit cards or pre-approved applications, this may point to someone assuming your son's or daughter's identity to establish credit.

THE SCOPE OF THE PROBLEM

Identity theft is the **fastest-growing crime** in America. And it extends across borders and involves other parts of the globe. The Federal Trade Commission (FTC) estimates that 10 million people were victims in 2002.

Determining the exact scope and financial impact of identity theft on people and businesses is hard. There's been disagreement over what defines identity theft (e.g., does a one-time joyride with someone's credit card equal identity theft?) and it's hard to calculate the impact when many incidents go unreported and it can take years for a series of incidents to be tracked and calculated.

The lack of a central command post for dealing with ID theft—it often involves local, state and federal offices—makes it difficult to understand the problem clearly. This **mechanical challenge** caused early government statistics to underestimate the numbers.

In 2002, the General Accounting Office (GAO) released a year-long study that found that complaints of identity theft to the FTC were up 33 percent and the Social Security Administration had a 500 percent increase in allegations of Social Security number fraud. According to the FTC, victims lost $5 billion due to ID theft in 2002. Businesses lost close to $50 billion dealing with the problem.

ID theft can be extremely **lucrative for criminals**. A clever thief can walk away with over $10,000 per victim. Other facts about ID theft released by the FTC in a survey:

- About **half of victims** do not know how the identity thief obtained their personal information. Nearly one out of four victims said their information was lost or stolen—including credit cards, checkbooks, Social Security cards or stolen mail.

- One out of 25 of those surveyed said identity thieves misused their personal information to **evade law enforcement**, such as presenting the victim's name and identifying information when stopped by law enforcement authorities or charged with a crime.

- The Identity Theft and Assumption Deterrence Act of 1998, which made identity theft itself a crime, designated the FTC as the central storehouse for identity theft complaints.

The FTC Identity Theft Clearinghouse (established in November 1999) received 161,819 reports of identity theft in 2002, up 88 percent from 86,198 in 2001. The FTC estimates it will receive 210,000 identity theft complaints in 2003.

- The District of Columbia has the highest incidence of identity theft, followed by California.

In 2002, there were 123.1 victims per 100,000 people in D.C., or 704 victims. In California, there were 90.7 victims per 100,000 people, or 30,738 people. In New York, there were 66.9 victims per 100,000 people, or 12,698 victims.

Most often, identity thieves use the victim's information to commit credit card fraud. However, more than one in five victims reported their information was used to commit more than one type of fraud.

How Your Information Is Misused[1]

(Percent of reports)

Credit card fraud: 42%

Phone or utilities fraud: 22%

Bank fraud: 17%

Employment-related fraud: 9%

Govn't documents or benefits fraud: 8%

Loan fraud: 6%

Other fraud: 16%

- About one in six identity theft victims said the thief used their personal information to open at least one new account, such as new credit card accounts, new loans or other new accounts.

- Over half of identity theft victims are **under age 40**. About 11 percent of victims are age 60 or older.

- According to the Social Security Administration Inspector General's analysis of the SSA's Fraud Hotline data, more than 80 percent of SSN misuse allegations were related to identity theft.

[1] Refer to the FTC's Web site at *www.ftc.gov* for more information. Some of this information was adapted from the site.

- On average, identity thieves misused victims' information for **about three months**. However, when the identity thief opens new accounts with the victim's information, the misuse lasts longer— more than one out of four of these victimizations lasted six months or more.

Despite the FTC's best efforts, there is no single database in the U.S. that captures all investigations and prosecutions of identity theft cases. Enforcement actions on identity theft law may be undercounted. Because identity theft is usually committed to **facilitate another crime**, criminals often are charged with those other crimes like bank, wire or mail fraud rather than with identity theft.

Reporting on ID theft is surprisingly low. Victims might first try to clear up the mess through their credit bureaus, credit agencies, DMV and the such. They don't necessarily run to their local police department or fill out the affidavit provided by the FTC for reporting the crime (more on this later). In 2002, 47 percent of those reporting identity theft to the FTC said they notified the police department, but only roughly one-third had a report taken; 53 percent of victims had not notified a police department.

Only about one out of four identity theft victims polled in a FTC-sponsored survey said they reported the crime to local police. Only about one in five said they notified one or more credit bureaus about the identity theft.

HOW THEY STEAL

There are so many ways for someone to steal your identity. Only about one in 100 identity thieves is ever caught. Think of all the people who hold they **key to your identity** via your Social Security number alone: your banks; credit card companies; credit bureaus; insurance companies; brokerage houses; doctors' offices; dental offices; phone companies; cable companies; fitness gym; local rec center; public library; school; baseball league; tennis club; DMV; **department and specialty stores** (e.g., Bloomingdale's, Victoria's Secret, Eddie Bauer) where you purchase items regularly with their card; apartment building manager; subscriptions that catalogue subscribers by their SSNs; airlines with your **frequent flyer programs**...and all those Internet sites you've joined using your SSN as an identifier or username.

This book will detail the How's, Why's, When's and Where's to ID theft, but here's a brief list of some of the places where thieves can get your information. Some are obvious areas of vulnerability; others are not. Become familiar with these things.

- **Mail**: Your mailbox—filled with incoming or outgoing mail—is an easy target. A thief can look through the mail for bills or bank statements and pilfer the information. **Check washing** is another method; a thief can wash out the ink on a signed check, change the amount and rewrite the check to himself. Watch out for those pre-approved credit cards that come in the mail, too.

- **Fraudulent change of address**: A thief can fill out a change-of-address form at the post office or with the victim's credit card company so the mail and bills get redirected to the thief's address or mail drop.

- **Trash cans and dumpsters**: Business and building dumpsters are attractive items to thieves looking for discarded letters with business and customer account information. A thief can disguise himself as a homeless person digging through garbage.

- **Onlookers**: Whenever you expose your ATM or calling card in a public place, someone might be looking. Criminals lurk around **ATM machines and public phones** in high-traffic areas for victims. They might even look from afar with the help of binoculars, camcorders or a zooming camera.

- **Lost or stolen purse or wallet**: If a thief comes across a lost purse or wallet, or steals it himself, he'll have a lot of personal information to use. This is when keeping certain things like your Social Security card and health insurance card (which often bears your SSN) out of your purse is key.

- **Inside jobs**: An employee of a business might illegally retrieve information that a business has collected for legitimate reasons. An **entry-level employee** at a financial institution, for example, might be

able to access others' personal information, and sell it to identity thieves.

- **Internet**: Computer-savvy criminals can use the Internet to hunt down victims easily. **Personal Web pages** are targets, and genealogical databases give thieves access to maiden names, which are often used as passwords to bank accounts and the like.

- **Skimmers**: Thieves who carry skimmers, devices that can read the magnetized strip from a credit card, bank card for account numbers, balances, verification codes, are hard to spot because they often work where you're using your card to make purchases. First your card is run through the regular credit card reader, then through the skimmer without you knowing.

- **Pretexting**: You might be duped into giving up your personal information over the phone with someone who disguises himself as a representative with a reliable company that you use, like your phone company, local department store or cable company.

In Chapter 4, we'll consider more details on each of these topics. In that chapter, the mechanics of ID theft get described in detail.

WHY THE INCREASE IN THEFT?

We live in an age of information and digitization; we've **traded privacy for convenience**. We buy gad-

gets to make remote transactions and have greater access to publicly available information.

Although the Internet makes it easier to steal data needed to pass as somebody else, ID theft was becoming a problem before surfing the Web became popular. At the heart of the problem is the issue of Social Security numbers being our sole code for our identity.

It's very easy to obtain Social Security numbers. Non-Social Security Administration uses of Social Security numbers have not been prohibited, so Social Security numbers are used as identification and account numbers by many entities.

The expanded use of the **SSN as a national identifier** has given rise to individuals using counterfeit SSNs and SSNs belonging to others for illegal purposes. Stolen SSNs have been used to gain employment, establish credit, obtain benefits and services and hide identity to commit crimes.

Web sites sell individuals' Social Security numbers, some for as little as $20. Self-regulatory efforts by information brokers have been ineffective in restricting the sale of sensitive personal information to the general public. Creditors, generally, have failed to adopt better policies.

> ID theft will worsen because there are indications
> that organized crime gangs are gravitating toward
> identity theft as a low-risk, high-payoff crime.

Stealing a credit card number is the easiest way to commit identity fraud. Thieves can find receipts left on tables in restaurants or in shopping bags, thrown away in a trash can or dumpster, or left behind at the gas pump. Identity theft, however, has gotten more sophisticated than that, which means you can't simply be super-careful about those receipts to protect yourself. The problem we face today is a result of many things that have been happening (or *not* happening) in the past 40 years.

In the 20th Century, a vast system of **third-party record keeping** arose. Personal information was collected and maintained by banks, doctors and hospitals, credit reporting agencies, pharmacies, utilities, insurers, employers and government agencies.

> In 1976, the U.S. Supreme Court, in *U.S. v. Miller*, ruled that Americans do not have a Constitutional right to privacy in personal data held by third parties. The court reasoned that when you open a bank account, you surrender your data to the flow of commerce. Absent statutory protection, the bank is more or less free to give your financial data to whomever it pleases. So, even though the information was about you, those that collected it and kept it, owned it. The Supreme Court ultimately extended this reasoning to telephone records and garbage.

In 1977, a bipartisan commission created by Congress when it enacted the **Privacy Act** recommended a comprehensive legislative package, concluding that protections were needed in such areas as financial, medical, communications and government records and Social Security numbers. It also recommended a national office to oversee and enforce privacy policy. As you can assume, most of those recommendations were not carried out.

TOO MANY BEDMATES

By 1990, the U.S. was the only nation with a law to protect the privacy of video rental records, but without a law to protect medical records. What we have today is a system by which each person is linked to one number and that number gets used to do everything, from buying houses and cars, to transferring money, selling on eBay, renting a video, getting a tooth extracted and registering your car.

> **ID thieves bribe clerks, steal from mailboxes, filch data from computers and garbage and raid personnel files.**

The underworld of "carders"— that is, hackers, who specialize in stealing and selling credit card numbers— is steadily growing. Some are connected to **organized crime groups** in Russia, Eastern Europe and Nigeria. Victimized Web sites include Western Union, Egghead, CD Universe and CreditCards.com. Identity thieves are using stolen credit card numbers to buy names, addresses and SSNs from legitimate infor-

mation brokers, and then use the fraudulently-purchased identifiers to commit identity theft.

The **consolidation of the banking industry** also has contributed to the upsurge in ID theft. As little banks get eaten up by bigger banks, the consolidation pinpoints one's personal information to huge databases and prevents a spreading-out of information that would help hide or scramble one's personal information. It also kills personal connections, changing the standard by which you are evaluated financially. Nowadays, people are more attached to their **impersonal FICO[2] score** than their reputation in town. You become a number rather than a face to which your identity is attached. The growing importance of consumer credit makes every Social Security number a potential charge account.

Financial institutions largely have **ignored federal regulators' recommendations** that they guard against would-be privacy invaders by asking customers for personal identification numbers (PINs) or passwords before giving out their personal data. Moreover, the government isn't pushing credit bureaus and credit issuers who gather and use private information to stamp out fraud. Until that happens, consumers' finances remain vulnerable.

[2]FICO stands for Fair, Isaac & Company, which develops the mathematical formulas used to obtain snapshots of your credit risk at any given point in time. These scores are the most widely used and recognized credit ratings, and they are used by the three largest credit reporting agencies (Equifax, Experian and TransUnion).

> Financial institutions continue to participate in telemarketing schemes in which customers are solicited for 30-day free trials and memberships, and then the telemarketer either charges it to the customer's credit card or adds a monthly charge to his or her mortgage statement.

There's a mixture of activities that should not be mixed. Would you want your bank selling your name and good reputation to retailers? Would you want the same institutions that track personal credit histories to **market personal information** to other companies? Probably not. But that's what they do. The lines between e-commerce, Internet-based financial services, banking, selling and buying have all blurred. Everything is computer-based, and everything is streamlined to a nine-digit number that puts you in a vulnerable center. It's no wonder that banks, credit bureaus and credit card companies don't like to talk about ID theft. They've been part of the problem.

> Credit bureaus should be required to notify people when someone accesses their file or they receive a bad credit report. But few states have adopted such needed reforms.

Only Colorado requires credit agencies to advise consumers of new bad-credit ratings. California lets people freeze their credit reports, preventing access to their files without permission. And only six states have taken the modest step of letting individuals get one free

copy of their credit report a year. Congress has failed to enact any of these measures.

WHAT CONGRESS IS DOING

So, what *is* Congress doing? Federal legislators have been slow to react to the problem. New legislation, which, among other things, would impose limits on the misuse of personal information and prohibit the unauthorized sale or display of Social Security numbers to the public, have been introduced but not passed. Combating identity theft will require a **multipronged approach** at the local, state and federal level, including the FTC, the Secret Service, the Postal Inspection Service, the FBI, the Office of the Inspector General of the Social Security Administration, the IRS's Criminal Investigation Division, as well as a range of other state and local agencies.

Congress passed the first federal law dealing with ID theft in 1998 called the **Identity Theft and Assumption Deterrence Act**, which we'll go over in more detail in Chapter 6. This statute has a sweeping substantive breadth that reaches all identity thefts that have a federal interest—even those involving state law felonies. But it still lacks the punch consumers really need.

> Violations of the Identity Theft and Assumption Deterrence Act are investigated by federal agencies (e.g., Secret Service, the FBI, etc.). The Department of Justice prosecutes the cases, usually through one of the U.S. Attorneys' offices.

California passed the first law to thwart identity theft in 1999. It prohibits businesses from printing more than the last five digits of an account number. The law applies to any new cash register. Existing registers must be in compliance by January 1, 2004. The law provides an exception for transactions in which the sole means of recording a person's credit card number is by handwriting or photocopying the card. Other states are following, but the U.S. government is considering legislation on the federal level.

Laws take time to get introduced as bills, passed into law and then enacted. One problem related to ID theft involves the **statute of limitations**, which is often based on the date of the criminal occurrence rather than date of discovery. ID theft takes a long time to emerge…and a long time to investigate. The gap between the criminal act and its discovery also allows offenders to cover tracks and destroy information that may otherwise prove invaluable to the investigative efforts.

In addition to a **lack of resources** as it relates to unraveling the complex underpinnings of an investment or securities fraud, criminal cases are not being brought because state and local law enforcement and prosecutorial agencies lack the technology and training to investigate and prosecute them effectively.

The U.S. Attorney General has announced that combatting the problem is a two-pronged step:

1) instigate a coordinated, nationwide sweep to prosecute cases involving ID theft; and

2) develop new legislation to enhance the penalties for ID theft.

In Chapters 6 and 7, we'll detail the **laws and agencies** available to protect you. You'll get a better understanding of the Fair Credit and Reporting Act, the 1998 federal Act, as well as a list of agencies that will respond to you in a case of ID theft.

PREVENTION STARTS WITH YOU

There are many ways to prevent ID theft, and it's important to incorporate as many theft-prevention tactics into your life as possible. It requires a level of **lifestyle alteration**. You can't simply run to Staples, buy a shredder and start shredding all of your junk mail and bank statements. You can't remove your Social Security card from your wallet and assume that keeps your number safe.

Protecting your identity is much more than that.

> Preventing ID theft today—in the age of the Internet and digitization—requires an array of changes at home, in the workplace and even among friends in large gatherings.

Later on you'll learn the mechanics of ID theft, the specific ways to prevent ID theft as well as how to incorporate those practices in your daily life. The key is to **prevent the theft** from happening in the first place, rather than dealing with it once it has occurred.

The most important tool you can have to prevent ID theft is **common sense**. Until government catches

up with laws to prevent theft, aid victims and pros-
ecute thieves, you need to rely on your own tactics
first. You have to hope that the minimum-wage input
clerk who processes your application for a grocery
store check cashing card doesn't get greedy. Or that
the minor federal functionary who files your son' ap-
plication for college financial aid doesn't get too in-
terested in the data on your form. Or that the person
working the Help Desk at an office superstore doesn't
decide to sell a crook the codes to access consumer
credit reports that contain the information needed to
assume your identity and destroy your finances.

Later in this book (Chapter 10), you'll find a chapter
on lifestyle changes that you should follow and check-
lists (in Chapter 11) for everyday living.

IN THIS BOOK

In the next chapter, you'll learn that no one is immune
to identity theft. It can happen to you.

This book gives you the tools for **making lifestyle
changes** in your daily routines in order to prevent
identity theft. It also give you the tools you need to
tackle an identity theft problem should you face one
in the future. You'll find real-life examples of people
like you who've become victims…as well as profiles
of the most pernicious thieves.

Also included in this book is information about how
IDs work, from your Social Security card to your
military discharge papers and driver's license. The me-
chanics of ID theft will be explained in detail; as well
as the effects of immigration on identities and the
horrific role terrorists have played in the growing prob-

lem; and the laws and agencies available to protect you.

In the end, you should feel better equipped to go about your daily transactions without too much worry. Getting **peace of mind** when it comes to any hassle in life—like identity theft—is about being a smart and aggressive consumer.

CHAPTER 2

IT CAN HAPPEN TO YOU...NO MATTER WHO YOU ARE

You can be rich, famous, a struggling middle-class unknown with major debts to pay off or a college student who has had a credit card for only a few weeks and be a victim of identity theft. You can be a two-year-old in diapers or an 86-year-old with false teeth and no memory. You could even be dead.

Because the world has become so electronic and automated, identity theft has become a crime that's enabled by computers, databases and the **impersonal nature of transactions** these days. Consider:

- The increased **availability of goods or services** that can be obtained on credit; and

- The **proliferation of computer technology** in our society that provides easy access to the information needed to commit many financial crimes, as well as a means for committing them remotely.

The personal identifiers most often sought by criminals are those generally required to obtain goods and services on credit. These are primarily Social Security numbers, names and dates of birth.

When you enter a bank, post office, grocery or corner five-and-dime store, **no one knows you**. You're a stranger whose ability to make transactions and purchases is often tied to a number—a credit card or bank card (if not cold hard cash). You are identified by the plastic cards you carry—your driver's license, club cards, credit cards and passports...instead of your recognizable face, reputation and family name.

Too many people think that they are too poor or in too much debt to ever become a victim of identity theft. *Why would someone want to impersonate me? I don't have any money. I don't own a home or a fancy car. I can hardly afford to make the minimum payments on my credit cards....*

When an Ohio college student applied for her first credit card upon starting school, the woman was surprised when she got turned down. Someone had already opened four credit cards in her name and racked up $50,000 in debt. That someone was her own father.

> Parents who've botched their own finances are increasingly tempted to dip into their children's credit. As co-signers, all they need is a birth date and Social Security number. Some parents put bills—cable, TV, utilities—in their kids' names.

The student knew her father was struggling financially after his divorce from her mother and the failure of his restaurant. And, typical of many victims of identity **fraud by family members**, she didn't want

to file a complaint against her father. So she persuaded him to consolidate the $50,000 credit card debt and pay it off by having his wages garnished.

Meanwhile, she had $30,000 in student loans of her own. She worried about her future—her ability to buy a car, get an apartment and meet a man who'd want to be with someone with $80,000 debt.

> People between the ages of 20 and 40 are most vulnerable due to their relatively high usage of electronic payment channels.

ALL IN THE FAMILY

Family members are an **attractive target** for identity thieves. Spouses have extensive access to each other's documents and personal information, and family members are frequently in each other's homes unsupervised. In-house thieves, however, rely on another element: that they won't get caught. These thieves hope that their family ties will protect them from law-enforcement. They assume, often correctly, that their victims won't press charges or avoid a confrontation with others in the family.

In Morena Valley, California, Judi Woodward was devastated to learn that her sister, Janet Goodpastor, had stolen her identity and that of their Alzheimer's-afflicted mother and used them to open fake credit card and utility accounts and forge checks. Woodward's credit was ruined and her mother paid the steepest cost: She was **evicted from her house**, was unable

to pass a credit check needed to get into a nearby assisted-living home and had a warrant out for her arrest over the bad checks written in her name.

> In the U.S., about 6 percent of identity theft victims who contacted the FTC in 2001 indicated that the person who had stolen their identity was a family member.

Although you're more likely to have your identity stolen by an opportunistic stranger, it's not out of the question for a **family member to impersonate you**. The hard part about being victimized by a family member is prosecuting. Do you sue your sister, brother or father for helping themselves to your good name and credit?

When it comes to **defining your family**, you need to be aware of people close to your family that might be able to access critical information about you. It's not just about your family, either. Your home is full of paperwork and documents that anyone can use to retrieve the information for committing identity theft. And they don't have to be blood relatives.

Controlling access to your home includes controlling who enters and leaves on a regular basis **with your permission**. An unscrupulous character might get to know you, get invited into your home or work in your home for a given amount of time...then later steal from you when you're not looking. Think about:

- housekeepers;

- security patrollers;

- gardeners;

- repairmen (cable, phone, utilities, appliances, computer, plumbing, etc.);

- **contractors**;

- decorators, landscapers;

- caregivers, **babysitters**;

- everyday deliverers (supermarket, drugstore, food, etc.);

- movers, installers;

- large item **deliverers** (appliances, TVs, furniture, etc.);

- mailman, garbageman;

- exterminator;

- utility meter reader (gas, electricity, etc.);

- pet groomer;

- tutor, **after-school teacher** (music, math, etc.);

- **athletic coach**, personal trainer, massage therapist, etc.; and

- friends, neighbors, children's acquaintances, etc.

Limit the number of people who have easy assess into your home. This means keeping keys and access codes to your security alarm away from most. Keep critical documents locked up in a desk drawer. Consider purchasing a **fireproof safe** for storing this information.

Protecting your children from dead-beat fathers or drug-addicted mothers who have the potential to steal from you and your children is a challenge.

Over the course of three years, Florida resident Kelli Pasqualetti-Heller began to receive letters from collections agencies demanding payment for utility, phone and cable companies. A furniture company sent an overdue bill. And the IRS demanded back taxes.

But the letters weren't addressed to her—they were addressed to her 11-year-old son who suffered from cerebral palsy. After hiring a private investigator, Pasqualetti-Heller learned that her son had had his identity stolen from his own father, who'd been using his son's Social Security number to make purchases. The woman fought with the bill collectors to get the charges removed, then went to the police. After two years of calling, e-mailing and faxing, Pasqualetti-Heller heard that her ex-husband was arrested and charged with three felony counts of identity theft.

This case is proof that a thief can be in the family...and target a minor child with no credit history at the start.

WHO'S A TARGET?

Identity theft, unlike many types of crime, affects all Americans, regardless of age, gender, nationality, race or income level. Victims include everyone from restaurant workers, telephone repair technicians and police officers, to corporate and government executives, celebrities and **high-ranking military officers**. What victims do have in common is the difficult, time consuming and potentially expensive task of repairing

the damage that has been done to their credit, their savings and their **reputation**. Be careful about calling identity theft a "white-collar" crime. This is misleading because the profiles of the thieves are as diverse as the people they victimize.

> An identity thief can be a lowly store clerk, a neighborhood teen with a fancy computer or your colleague at work with too many bills to pay. But these thieves also include organized criminal groups, street gangs and convicted felons.

Because laws haven't been passed quick enough to address the growing severity of the crime, the probability of high financial gain versus low sentencing exposure opens the door for more thieves. And, until more uniform and severe laws emerge to catch, prosecute and punish identity thieves, the **incentives to steal** will outweigh the risks of being caught.

An identity thief can be sophisticated in his methods, or **low tech by simply dumpster diving** to obtain someone else's personal information. An identity thief may not even think about committing the crime until he or she comes across a misplaced purse, a dropped wallet or a stack of mail placed in the wrong mailbox. If a potential thief has access to personal information but doesn't have the know-how to pull of a scheme, he may **sell the information** to someone who does know how to pull it off.

> With the proliferation of computers and increased use of the Internet, many identity thieves have used information obtained from company databases and Web sites. A thief might access a public Web site that contains information in the public domain that can be used to create a false identity. He might flip through employee files at work and get what he needs to impersonate. She might pretend to be your kids' ballet instructor and take your personal information—as well as your children's—and use them to establish credit and a new ID.

According to the Secret Service, the method that may be most difficult to prevent is theft by a **collusive employee**. Individuals or groups who wish to obtain personal identifiers or account information for a large-scale fraud ring will often pay or extort an employee who has access to this information through their employment at workplaces such as a financial institution, medical office or government agency.

When you think of all the people who have your personal information on file, it can be frightening. And to think of all the people who can access that information either directly or indirectly is doubly frightening. Strangers you meet in your daily transactions can be your thieves. There's no one target.

You're **the target** of an identity thief.

> ID thieves do not discriminate. Whether you're young, old, rich or poor (famous or John Doe) you are at

> risk. Celebrities like Tiger Woods and Lara Flynn Boyle
> have been victims. Dead people from the World Trade
> Center attacks have been victims.

But there is one thing that can make you a greater target for ID theft: your name. The more common the name, the easier the target. According to the U.S. Census Bureau:

- The most **common family names** include: Smith, Johnson, Williams, Jones, Brown, Davis, Miller, Wilson, Moore and Taylor.

- Most common male names: James, John, Robert, Michael, William, David, Richard, Charles, Joseph and Thomas.

- Most common female names: Mary, Patricia, Linda, Barbara, Elizabeth, Jennifer, Maria, Susan, Margaret and Dorothy.

Your **location** might elevate your risk as well, as the largest number of ID theft complaints have typically come from California, New York, Texas and Florida.

YOUNG AND OLD

As we've already seen in some cases, young children can be victimized. College students are fat targets, too.

> Young people whose parents have money problems
> should consider running regular credit reports and

> request that the three major credit agencies notify
> them when new accounts are opened in their name.

When you arrive on a **college campus** for the first
time, chances are you'll get a dozen offers to open a
line of credit with a bank. But the deluge of credit
card offers coupled with **students' carelessness**
exposes college students to identity theft.

In a study for Chubb Insurance Company, Impulse
Research Corp. surveyed 208 college students over
the Internet and learned that **49 percent of college
students receive card applications daily or weekly**.
Some 86 percent of those surveyed said they receive
card applications a few times a month. Of those sur-
veyed, 30 percent said they trashed the applications
without destroying them. Chubb also learned that 75
percent of college students are approached by repre-
sentatives of card issuers who ask students to fill out
applications with personal information, including So-
cial Security numbers, in order to be considered for a
card. In some instances, the application takers are not
really employed by card companies, but are posing as
employees to obtain information.

> Nearly 30 percent of students rarely, if ever, recon-
> cile their credit card statements.

The problem for students is that many colleges use
Social Security numbers as a student's identification
number, which is required to access grades, log on to

campus computers, gain access to dining halls and other school activities, take exams and see your test scores on a **hallway posting**.

Those same ID numbers are printed on student ID cards. Adding to the odds against college students is their carelessness when monitoring their accounts and checking for fraudulent activity.

> Some university orientation activities make it easy for students' personal data to fall into the wrong hands. Various vendors use these events to push credit card applications to new and returning students, often with bonuses like free T-shirts and other incentives.

A university might not be so good about screening these vendors before they set themselves up and **prey on students**. It's possible that anyone can set up a table and look like an authentic vendor from a reputable bank. So, by filling out an application, which, in most cases, asks for your Social Security number, you could be handing valuable information to an identity-fraud operation.

At the other end of the spectrum, the **elderly are very easy targets** for thieves. There have been many cases in which elderly people have been victimized by their caretakers. For example, a Louisiana woman used the credit card of a 90-year-old New Orleans woman under her care to illegally withdraw several thousand dollars from ATMs. The thief was eventually booked with identity theft, unauthorized use of a credit card

and exploitation of the infirm. She had used the elder woman's Social Security number to obtain a personal-identification number that allowed her to make ATM withdrawals using the woman's credit card.

In a case under federal indictment in the Eastern District of Michigan, *United States v. Billings*, the defendants and others allegedly worked together to identify houses in the metropolitan Detroit area that were owned free and clear by elderly people. They would allegedly steal the identity of the true owner and then strip the equity out of the houses without the owner's knowledge or consent. How did they do this? The criminals **re-financed** the property, withdrawing equity and obtaining a mortgage in the owner's name, and then defaulted on the mortgage.

In a federal prosecution in the Eastern District of North Carolina, *United States v. Hooks*, a man stole mail from senior citizens throughout North Carolina, used the biographical information contained in the **stolen mail to produce fake drivers' licenses** and counterfeit checks, and then used the licenses and checks to withdraw money out of their bank accounts. To produce the licenses, the man had obtained an official North Carolina Department of Motor Vehicles license machine. (He later claimed that he purchased the DMV machine on eBay.) In this case, which the United States Secret Service investigated, the loss resulting from the criminal's conduct totaled $177,472.63. He ultimately pleaded guilty to mail theft, production of false identification documents, and use of false identification, and was sentenced on to 63 months imprisonment.

And, in another case involving the elderly, *United States v. Robinson*, the defendant took a job as a **live-in com-**

panion for an elderly woman. After the elderly woman was hospitalized, the defendant obtained and used credit cards in the elderly woman's name, stealing $47,051.35. The thief pled guilty to access device fraud and production of false checks, and was sentenced to 31 months imprisonment.

Older Americans will become an increasingly attractive target by criminal elements given that 70 percent of our nation's wealth is controlled by those 50 years of age and older.

Often, the level of diligence in monitoring personal finances decreases among the elderly or, after discovering the fraudulent activity, some are embarrassed and unsure of the steps necessary to report the compromise.

Criminals do not steal the identities of the elderly so they can pretend to be old and wise. They do it because senior citizens are more likely than most of us to have **significant assets**—savings, investments, paid-up mortgages, good credit and Federal entitlement checks. Some senior citizens are easier and safer to rob because they are less sure of themselves, more trusting and less aware of simple precautions. They may be less likely to review their monthly financial statements. They may hesitate to take action if they do find something wrong because they are afraid a relative is responsible for robbing them, or because they are afraid they will make their families feel they can no longer be trusted to live independently.

> Remember: Identity theft is an "enabling" crime, one that permits criminals to commit other crimes more effectively. Those crimes may range from passing bad checks and defrauding credit card companies to horrific acts of terrorism.

A MAN IN PHOENIX

Preying on the alone and elderly is often a **tactic of telemarketers**. When you're old and lonely, you don't mind answering the phone to chatty marketers who'll pay attention to what you have to say. But when a telemarketer mixes marketing with thievery, it's particularly sad. That's what happened in Phoenix, Arizona, where a man purposely engaged in telemarketing activities and targeting individuals who hoped for something that would give them a better life.

The man's scheme generally involved an amount of money less than $500, which made the victim less likely to pursue legal action. He would send correspondence to these seniors bearing the words "Social Security Administration" and the **official SSA seal**, advising them they had been approved to receive an additional SSA benefit check, but they would have to pay a "processing fee" ranging from $9 to $99. In some cases, he requested banking information in order to process the fee, and after receiving that information, he withdrew money directly from their checking accounts.

From October 1994 to October 1998, this same man mailed letters and made phone calls using the names *Rainbow International*, *Magic Numbers* and *Future Con-*

cepts to tell seniors they were part of a group that could participate in pooled lottery winnings upon payment of a processing fee. When individuals mailed checks to one of several mailboxes he maintained at commercial mail receiving companies, he used their signatures and created fictitious authorization forms to gather information, and again withdrew money from their checking accounts. In all, he stole more than $1.3 million. After a federal investigation resulted in a **14-count indictment**, the man pleaded guilty to mail fraud. The judge termed his activity "despicable," and sentenced him to 36 months in jail.

CHEWING THE FINGERTIPS

Later, you'll see how biometrics are becoming a tool for preventing ID theft. *Biometrics* is a group of technologies that identifies an individual by a physical attribute, such as the sound of his or her voice, eyes, face or even DNA. The majority of **biometric identification systems** in effect today make use of fingerprint recognition. So, if you're trying to "erase" your identity when confronted with a fingerprinting device, what do you do? You start chewing off your fingers. That's what one ID thief tried.

In 2002, a Nigerian husband and wife team living in the suburbs of Philadelphia were accused of stealing hundreds of identities through their airport cleaning business. They purchased merchandise with bogus credit cards, and had those items delivered to about 50 empty houses.

They called themselves Adegboyega and Bolanle Joshuasville—which were made-up names. The man's fingertip-chewing was intended to prevent authori-

ties from finding out their true identities when they faced a federal indictment for immigration violations. Their real names: Olugbemiga Adegoke Olusajo and his wife, Bolanle Elizabeth Onikosi.

> Financial crime is so rampant in Nigeria that the U.S. Secret Service has opened an office in Lagos to work with Nigerian authorities to head off burgeoning e-mail computer fraud. There has been a pervasive West African influence in the U.S.'s rampant growth of identity theft—and a disproportionate number of ID thieves are from Nigeria.

Another Nigerian man also living in the suburbs of Philadelphia took a job with the local Social Security office and ripped off numbers to use in an identity theft ring. After he took personal information from SSA computers, the man helped others open or assume credit card accounts. Of particular interest to the thief: the maiden names of cardholders' mothers.

Many credit card firms use those maiden names as verification for telephone transactions. In Chapter 8, you'll learn how to avoid using the age-old mother's maiden name when asked for it. Just as Social Security numbers have become too commonplace as codes of access to personal information, a **mother's maiden name** has also become too commonplace as codes of access to the same information.

THIEVES AT WORK

The close relationships we make at work—and the ones we don't make—allow the workplace to be an-

other vulnerable spot for potential identity theft victims.

> Employers are experiencing an increase in all types of security breaches, including theft of employees' personal information. An ex-employee of a major insurance company recently downloaded 60,000 personnel files and tried to sell them on the Internet for $50 each. He faces 45 years in prison.

Some employees will post personnel information online because they are mad at their employer or a specific coworker. Others sell the information or steal it to get credit cards.

Employment information is vulnerable today as the workplace expands to include remote locations. People are working from their homes, cars, hotel rooms and so on. They're dialing into their desktops remotely, using wireless connections and exposing their computers to hackers and interceptions every day. Information becomes increasingly easy to steal. This **expanding workplace** makes it that much harder for companies to protect information. This is especially true when electronic payroll and Human Resources data can be assessed remotely.

Vendors can also be culprits. Employers that contract out their **payroll functions** to a third party increase the number of individuals who have access to personnel data. The good news is that vendors can implement privacy policies and procedures that would be

too costly and onerous for employers. Consider some situations:

- An employee in South Carolina's Bureau for Child Support Enforcement was sentenced to probation for using a coworker's identity to get utility service;

- Employees who worked for First USA Bank, MBNA America, Discover Card, Chase Manhattan Bank, Household Finance Corp. and American Express were charged by a federal grand jury with crimes ranging from bank fraud to embezzlement to credit card fraud that cost these banks at least $665,000;

- A temporary worker at St. Luke's Hospital in Allentown, Pennsylvania rang up more than $3,000 in charges in another woman's name after the worker stole the woman's identity on a **hospital computer**; and

- Retirees and other former Department of Human Services workers in the state of Illinois were among the victims of an identity theft scam involving an ex-DHS employee who filched the names and Social Security numbers of about 5,000 colleagues.

Bank employees who are involved in identify theft typically steal directly from a customer's account or sell private financial information, such as a person's Social Security number, date of birth and credit card account numbers. It doesn't matter which side of the table you are on—employee or customer—you are a target nonetheless.

THE FINANCIALLY WEAK

You don't have to have a villa or drive a fancy car to be a target. The great majority of identity theft victims are from the **hard-working middle class**—the people who struggle to make ends meet, put their children through good schools, keep insurance and mortgages and bills paid up, stress over every dollar spent on superfluous items, and dream of a two-week vacation—even if it's spent relaxing in the comforts of home.

With consumer debt at an all-time high, many people **carry large balances** on their credit cards, which makes it easier to overlook suspicious purchases.

> If you're not used to scrutinizing every nickel and dime listed on your credit card statements—even if you only pay the monthly minimum and don't intend to pay off your debt anytime soon—you need to change your habits. Otherwise, you won't notice that $200 outfit or $600 car stereo system added to your list.

CREDIT REPAIR SCAMS

For two years, North Philadelphia's Darryl Brown promised people he could get them a new car even if they had bad or no credit. But he was using stolen SSNs to obtain fraudulently automobile loans.

When federal prosecutors moved in, Brown quickly surrendered and helped prosecutors snatch 11 asso-

ciates in an identity-theft ring that trashed the credit records of 59 people and defrauded 11 car dealers in Pennsylvania and New Jersey of 80 vehicles worth $2.8 million. Brown didn't get off so easily: He was sentenced to a 15-year no-parole prison term and was ordered to pay $1.2 million restitution to seven auto dealers, five insurance companies and six financial institutions that lost money on vehicles he helped his clients buy but that were seriously damaged or never recovered.

> Be wary of credit repair outfits that guarantee to fix your bad credit in a short while. With the growing number of Americans going deeper and deeper into consumer debt every year, credit repair scam companies have cropped up at record rates.

You'll find a lot of discussion about credit bureaus, credit watch services and credit repair shops throughout this book. These establishments are involved in every part of ID theft—from perpetuating the problem to assisting in its solution. There are good and bad aspects to these companies...and you need to be able to **use these companies' services** to your advantage while avoiding all the scams abound.

WANNABE CELEBS AND ATHLETES

The list of potential ID theft targets is long. Anyone can be victimized. Oprah Winfrey and Martha Stewart lost theirs to the same busboy. Robert De Niro had his swiped by a movie double. Tiger Woods had to

go to court to get his back. And we're not talking cars, wallets or golf clubs. We're talking identities.

In a high-profile case, a high school dropout used library computers, the Internet and cell phones to collect personal information about more than half of the world's 400 richest people, using the list in "Forbes" Magazine. Abraham Abdallah, a busboy in a local restaurant in Brooklyn, New York, was able to successfully obtain personal information such as names, dates of birth, Social Security numbers, phone numbers, and sometimes bank and broker- age account information by using the Internet and other sources. While working as a busboy, Abdallah stole credit card numbers of various customers and then used those credit cards to order and purchase a variety of items over the Internet.

And that was just the beginning. He stole money and products worth at least $100,000 but was aiming for millions before he was caught. Warren Buffet, Oprah Winfrey, Stephen Spielberg, Martha Stewart, Paul Allen, Michael Bloomberg and Ted Turner were among his victims—many of whom didn't even know their ac- counts had been compromised (because they're so rich and don't control their money as closely as you and me).

When thieves swiped $5,000 worth of personal items from his luggage in early 2001, Anderson Cooper got over it quickly. The son of heiress Gloria Vanderbilt and now the co-anchor of CNN's American Morn- ing, Cooper was too busy hosting ABC's *The Mole 2*

to worry about losing clothing and a **laptop computer**. (Note: If you left your laptop on the Boston T, would you know what personal information was on it—exactly?) What Cooper didn't realize was that the crooks had also taken at least two of his personal checks, allowing them to create phony checks and loot $25,000 from his bank account over a nine-month period.

> If you're not on top of your finances and live a busy life, you're more likely to miss money draining from your account over a long period of time.

Cooper finally noticed checks being drawn from an account he rarely used. When he called his bank he discovered that about 26 fake checks had been passed, as well as dozens of fraudulent wire transfers of money. And because Cooper did not report the losses **within three months**, the bank repaid only about $3,000.

> This book will teach you how to look closely at your finances and pick up on clues that could indicate a breach in your personal identity. No one can afford to lose the money, time and effort it takes to restore a good name, credit and probably a few bucks.

A man who ran up $81,000 in credit card bills in the name of an Atlanta Hawks basketball player also stole from TV, movie and rap-music star Will Smith. In

another case, Ishman Walker led a million-dollar identity theft ring in Chicago. First he stole a Citibank account number in the names of Michael Jordan and his wife, Juanita. Then he tried to find someone who looked enough like Jordan to raid the former Bulls star's fortune.

He didn't get that far. Walker was further accused of draining the accounts of at least 30 other people of more than $1 million. How did he do it? He **bribed workers in the secretary of state's office** and at least four banks to obtain the IDs and financial information for his scam.

If you have teenage children involved in after-school sports or club teams, be wary of coaches who ask for too much information. In upstate New York, a man was caught using two 18-years-olds' identities to open a utility account and obtain Direct TV. He also held a baseball scouting camp for wannabe professional players (who all believed the camp was for major-league baseball tryouts), and then took their money...and their identities.

Doctors also have to worry about thieves in the system, as **physician identities** are accessible from sources such as state medical boards' Web sites, local physician directories or even the Yellow Pages. Physician names, as well as copies of medical licenses and office addresses, also can be stolen from **hospital personnel files**. Criminals use the documents to obtain Medicaid provider numbers, then inform the state

Medicaid program that the physician has a new address where payment should be sent.

Criminals also steal names, Social Security numbers, or identification numbers of **Medicaid and Medicare beneficiaries**.

CORPORATE SECURITY

To ultimately protect our identities, we have to rely on the companies with whom we do business to protect the critical information they keep on us. A company that has thousands—or even millions—of customers, has a lot to protect. One security breach could expose all those identities. Most companies use passwords to safeguard your confidential information, but when they are weak and insecure that information can get stolen. And it can get stolen by someone from within the company's walls or outside.

> In yet another scenario, a thief or organization can pose as one of the top 1,000 companies in the world by mirroring that corporation's Web site, but slightly altering its URL or becoming a new division with a new shipping address.

Well-organized thieves have a **network of delivery locations**, trucks, equipment and personnel to move and hide anything they obtain. Once groups or individuals establish a proper association for credit and billing, losses can be overwhelming to any company unfortunate enough to be victimized.

Corporate identity theft is not the focus of this book, but hopefully corporations will spruce up their anti-ID theft security in conjunction with consumer awareness about personal identity theft so that together, the room to move clandestinely as someone else will get smaller.

If you're **running a business**, you'll find that protecting your personal identity in the office is as important as protecting it in your personal life. The lifestyle changes you make in general must include how you work, deal with employees and expect your office to run effectively and safely. Chapter 9 includes some advice for employers, but for the most part, the changes you make to your personal life can easily translate to everyday office practices as well.

When you deal with other companies as a customer, you usually have to deal with passwords. In an ideal world your password should be unique and secret, something no one else can guess. But in reality most passwords are easy to guess: your initials, last name, pet's name or PIN number. Moreover, too many write down their passwords because they have access to lots of computer systems at work—e-mail, accounting, the Internet—and they can't remember them. Later in this book we'll look at how IDs work and the ways to manage your passwords effectively. When you understand the mechanics of ID theft, you come to see the ways in which you can prevent it.

CONCLUSION

Anyone is a target for ID theft. Now that you know you can be the next victim, you're probably wondering *why* this problem has gotten so bad so quickly?

The simple answer: existing ID tools are easy to buy, sell and replicate.

But the longer answer is complex and multifaceted. In the upcoming chapters, you'll get a full view of the problem and come to understand the reasons behind today's fastest growing crime...and what you can do about it.

3

THE PROBLEMS CAUSED BY EXISTING ID TOOLS

In this chapter, we'll consider the main mechanical reason that ID theft is such a problem in the United States: **Fake IDs are easy to make**.

Even though the U.S. has the most complex and extensive consumer credit system in the world, the trillions of dollars rely on a handful of basic identification documents that everyone shares. The "**breeder documents**" basically consist of one federal ID (the Social Security number), one state ID (the driver's license) and one local ID (the birth certificate).

We'll start with the ID system that poses the greatest danger of theft and work downward.

SOCIAL SECURITY NUMBERS

The Social Security number (SSN) was created by the 1936 Social Security Act as a nine-digit account number assigned to each American worker by the U.S. government for the purpose of administering the **pension benefit programs** known broadly as *Social Security*. Even in the 1930s, Congress recognized the

dangers of widespread use of SSNs as universal identifiers.

At first, SSNs were intended to be used exclusively as a means of tracking earnings and crediting worker accounts. Over time, however, SSNs were permitted to be used for purposes unrelated to the administration of the Social Security system. For example, in 1961 Congress authorized the Internal Revenue Service to use SSNs as taxpayer identification numbers.

Oversight agencies like the Government Accounting Office (GAO) repeatedly recommended that the federal government use SSNs as a unique identifier to reduce fraud and abuse in other federal benefits programs. The government was soon using the SSN as an ID for a broad range of **wholly unrelated purposes**—food stamps, Medicaid, Supplemental Security Income and child support enforcement.

By the early 1970s, a major government report on privacy outlined the risks posed by the use and misuse of the SSNs. The report, titled *Records, Computers and the Rights of Citizens* described the growing use of the SSN as a "Standard Universal Identifier." The report noted that **private-sector use of SSNs** was promoting invasive profiling (and this was before widespread use of electronic databases).

The report recommended several limitations on the use of the SSN and suggested that legislation should be adopted "prohibiting use of an SSN, or any number represented as an SSN for promotional or commercial purposes." No such law emerged.

By the 1990s, in an effort to learn and share financial information about Americans, companies **trading in financial information** were the largest private-sector users of SSNs. For example, the three largest credit bureaus in the U.S.—Experian, Equifax and TransUnion—maintain over 500 million files, with financial information on almost 90 percent of the American adult population. These files are organized by individual SSNs. This information is freely sold and traded, with very few legal limitations.

> These users create the environment in which identity theft based on SSN abuse thrives. The financial service industry's misplaced reliance on SSNs, lax verification procedures and aggressive marketing enable identity thieves to obtain your personal information.

By the early 2000s, people were beginning to realize that **over-reliance on SSNs** was causing—not preventing—identity theft.

In May 2001 congressional testimony, Cory B. Kravit—a student at the University of Florida—described how his alma mater used SSNs.

Students are required to provide their Social Security numbers for virtually everything ranging from registering for classes to ordering a Little Caesar's pizza using one's student debit account. …the Social Security number of each and every student is freely available to numerous individuals within the university. This

list includes professors, teaching assistants, dormitory desk clerks, Residence Assistants (RA's), registrar staff, library staff, Little Caesar's Pizza employees, bookstore employees, mail carriers and the general student body.

Bad results were already taking place. In 1998, the University's police department arrested a **desk clerk** working at one undergraduate residence hall after he stole the identities of 23 students. The clerk was charged with mail theft and credit card fraud after spending nearly $70,000 without the students' knowledge.

Misuse of SSNs is a crime—and it **cuts across demographic and geographic lines**. But, until the early 2000s, many people in government and the personnel offices of big employers didn't pay much mind to SSN crime.

HOW TO READ A SSN

According to the SSA, the first three digits of every Social Security number denote the **area or ZIP code** in the state where the application was filed. Prior to 1973, SSNs were assigned by field offices and the number reflected the state where the card was issued, starting with the lower numbers in the East and increasing geographically westward. Someone from California shouldn't have a SSN that starts with a "1" or "2."

The middle two digits may be most helpful in authenticating a Social Security cardholder. These follow the geographically based three-digit area number. According to the SSA, the two middle digits re-

flect the chronological order in which a number is assigned within a given geographic area. The group numbers are given first in odd-numbered pairs "01" up to "09," then they switch to even-numbered pairs "10" up to "98." Once used, the pair order reverses, starting with even-numbered pairs "02" through "08" before reverting to odd-numbered pairs of digits from "11" to "99." All the while the group numbers are followed by another set of four-digit serial numbers.

It sounds complicated, but SSA publishes on its Web site a monthly table that lists the highest area and group numbers assigned in a given region. So, a 20-year-old with low SSN middle digits that might match the **chronological assignment pattern** for someone much older who lives in the region should be fairly easy to verify by a utility company, bank or creditor.

And for that the only technology needed would be access to the Internet.

BIG RISK: SSNs OF DEAD PEOPLE

Perhaps the biggest pressure point for SSN abuse is after a legitimate SSN owner dies. It often takes the federal government several months to mark the death in its databases—in the meantime, crooks can use the dead person's SSN for illegal purposes.

The SSA maintains a **Death Master File** (DMF), consisting of 60 million names and SSNs of dead people. Businesses and law enforcement agencies are always anxious to get this information in the most current form. So, the database is updated on several schedules—quarterly and monthly; and it's available

for sale by the National Technical Information Service. Its records contain important personal identifiable information, including the name, Social Security number, date of birth, date of death, state or country of residence, ZIP code of last residence and ZIP code of the dead person's heirs.

> There are limits to the DMF database. Its records have over a 3 percent error rate, and provide information chiefly on those who died after 1960. As the NTIS Web site states, "The Social Security Administration does not have a death record for all persons; therefore, SSA does not guarantee the veracity of the file. Thus, the absence of a particular person is not proof this person is alive."

In his November 2001 congressional testimony on reforms to the DMF, Marc Rotenberg, Executive Director of the Electronic Privacy Information Center, said:

> It is remarkable that such a data goldmine is made publicly accessible by SSA and is a sobering reminder of the urgent need to restrict access to sensitive personally identifiable information. Rather than focusing attention on how these records can be transmitted more rapidly and accurate to commercial and private users, Congress must first consider placing limitations on the use and access to such data.

A fair question emerges: Who benefits more from the DMF—government agencies and credit companies…or ID thieves?

Few banks, credit card companies or other commercial firms subscribe to the DMF directly. Instead, they get the information indirectly—through credit bureaus like Experian, TransUnion and Equifax. This is another point at which those three exert **a lot of influence**.

The credit reporting agencies make the data from the DMF available only for subscribers to their **proprietary fraud prevention products**; in contrast, death information reported directly to the credit reporting agencies by credit issuers and family members was made available to all their users—along with other credit information on a customer's credit history. This information was generally provided within one to two billing cycles.

WHAT THE SSA IS DOING

In fiscal 2000, the Social Security Administration's office of the Inspector General received 92,847 complaints. Over half of these—46,840—were allegations of SSN misuse, and another 43,456 were allegations of program fraud, which often include implications of SSN misuse.

By mid-summer 2002, the SSA had mailed 750,000 letters to the nation's employers that said some of their workers' names and Social Security numbers didn't match the federal database. The number of "no match" letters sent out that year was up dramati-

cally from the 110,000 sent out in 2001, according to
Social Security spokesman Mark Lassiter.

> The SSA has no enforcement powers, and it cannot
> share information with the Immigration and Natu-
> ralization Service; but the IRS can. Under Section
> 6721 of the Internal Revenue Code, employers can be
> fined $50 for each invalid Social Security number,
> up to $250,000 a year.

In his July 2002 congressional testimony, James G.
Huse, Jr.—Inspector General of the Social Security
Administration—described the problem of SSN mis-
use:

> The public display of SSNs—on identifica-
> tion cards, motor vehicle records, court docu-
> ments, and the like—must be curtailed im-
> mediately. Those who use the SSN must share
> the responsibility for ensuring its integrity.
> While we cannot return the SSN to its simple
> status of a half-century ago, we can ensure
> that identity thieves and other criminals can-
> not walk into a municipal court house and
> walk out again with the means of commit-
> ting state-facilitated identity theft. The cost to
> the victims of identity theft, and to all of us,
> is too great. And the potential for these num-
> bers to be used to commit acts of violence
> and terrorism is unthinkable.

And in an earlier testimony on the same topic a year
earlier, Huse had suggested a more specific solution
to the risks posed by SSN misuse:

With certain legislated exceptions, no private citizen, no business interest and no ministerial government agency should be able to sell, display, purchase or obtain any individual's SSN, nor should they be able to use any individual's SSN to obtain other personal information about the individual.

DRIVER'S LICENSES

While the Social Security number is the cornerstone of ID theft, a driver's license is the **most practical tool** of the crooked trade.

In the U.S., driver's licenses are issued by individual states, so regulating them is logistically more difficult than regulating SSNs. In April 2002 congressional testimony, Betty Serian—Vice Chair of the American Association of Motor Vehicle Administrators—described the ID theft problems that driver's licenses pose:

the driver's license has become the most requested form of ID in the U.S. and Canada. For example, financial institutions require it to open an account, retail outlets ask for it when you want to pay by check, and the airlines demand it before you board a plane. In a recent (April 2002) poll conducted by Public Opinion Strategies, 83 percent of the American public noted that they used their driver's license for purposes other than driving.

The U.S. has more than 200 different, valid forms of driver's licenses and ID cards in circulation. In addition, each of the 50 states and D.C. have **different**

practices for issuing licenses. Although the current system allows for reciprocity among the states, it lacks uniformity. Individuals looking to undermine the system can shop around for licenses in those states that have the weakest security and background checks.

The lack of standard security features on a driver's license allows ID thieves to **exploit the system**. While all states use a variety of security techniques, it is difficult for law enforcement and for those issuing a new license to verify the validity of a license from another state—not to mention the identity of the person holding the license.

The American Association of Motor Vehicle Adminstrators (AAMVA) has been investigating, implementing and operating information systems since the late 1980s. Through its technology subsidiary, AAMVAnet, the association manages and operates the Commercial Driver's License Information System (CDLIS), which is designed as a clearinghouse for commercial drivers. CDLIS was designed to limit any given commercial driver to one and only one commercial driver's license and it has worked well for this purpose.

> In the mid-1990s, AAMVA began exploring the possibility of having a clearinghouse of all drivers within the U.S. in order to better control the problem driver population.

The AAMVA recommends that driver's licenses should have **common identification features**, so that de-

partments of motor vehicles (DMVs) will be able to recognize fraudulent cards more quickly and easily.

The AAMVA has also asked that driver's license databases be **linked state to state**. Law enforcement officials would be able to access personal identification such as name and address and would also have access to the license holder's driver history.

The Security Industry Association's (SIA) Homeland Security Advisory Council has also recommended that Congress enact legislation to set national standards. Among the baseline standards, the SIA suggests:

- uniform appearances such as types of ink, paper, size and shape;

- data to be included on the card's database, including a photograph, address, date of birth and a digitally-imprinted thumb print;

- incorporated technology such as holograms, microchips, magnetic stripes, barcodes, proximity cards and readers;

- production requirements such as material specifications; and

- protocols and conditions for identification issuance such as **background checks**, or the establishment of a two-day waiting period.

Driver's licenses use photographs, height, age, weight and address to verify that the cardholder is actually who he claims to be. But biometrics, such as fingerprints and digital signatures, can add additional layers

of security that traditional identification documents cannot.

Security technology providers propose that magnetic stripes, barcodes or **electronic "smart" chips** be integrated in driver's licenses to hold identification information. Since these technologies locate an individual's data on the license itself—instead of at a central DMV computer system—they make ID theft more difficult.

From the DMVs' perspective, moving away from central databases and toward smart cards is similar to the move in corporate America from mainframe computers to networked stations. The decentralized system is just as powerful (if not more so) and much less susceptible to crashes and other malfunctions.

HOW CROOKS GET FAKE LICENSES

ID thieves can get usable driver's licenses illegally in various ways:

- Purchase a counterfeit license;

- Obtain (most often by theft) and altering an existing license;

- Obtain a valid license by presenting fraudulent breeder documents and employing other devices usually provided by middlemen; or

- **Exploit loopholes** that permit undocumented residents to obtain a valid driver's license legally.

These are all tactics for getting or altering legitimate licenses. Beyond these tactics, there are thousands of ways to obtain simple fake licenses. Web sites offering "novelty IDs" abound on the Internet, often with foreign locations, such as the Czech Republic or Australia. To any savvy computer user, many sites sell driver's license templates—some for all 50 states— for as low as $75.

Fake driver's licenses were supposed to go away once states began issuing new secure driver's licenses and IDs that feature digitized photos, signatures, holograms and bar codes. But crooks are making authentic-looking counterfeits and most store clerks don't check closely enough for security features.

Fake IDs used to support stolen credit cards or kite stolen checks can be made on a computer and based on the new secure format. No more slicing lamination with razor blades, altering birth dates and gluing grainy pictures to a stolen ID.

Fakes can differ from the real thing in tint, print size, holograms and sharpness of the image. But all are features the **average cashier probably will not check** if there is a line behind the crook.

Police from Washington state to Florida have seized rooms of computer equipment, stolen IDs, stolen checks and records.

The officers confiscate the usual equipment of any home-based business: desktop and laptop computers, printers, fax machines, scanners, digital cameras, graphics and bookkeeping software, photo quality paper. The unusual finds are the **media of ID theft**: stolen checkbooks, sheets of blank checks and several credit cards.

Newer ID cards also come with other security features—invisible markings that show up under black light…or barcodes that convey driver data. Police and businesses eventually will be able to scan the bar codes instead of bothering with the front.

Prices are higher for everyone. In Washington state, before new-format licenses were launched in 2000, the fees for driver's licenses increased from $14 for four years to $25 for five years. The fee for a state ID card rose to $15 from $4.

WHAT STATES ARE DOING

While the federal **Drivers Privacy Protection Act** prevents DMVs from selling personal information to commercial entities, the information is often shared with other government agencies and—eventually, sometimes—with private sector firms.

But most states are trying to shore up the security.

Among license administrators, North Carolina has the reputation for the loosest identity document standards. Supposedly, some 388,000 people hold North Carolina licenses emblazoned with the Social Security number 999-99-9999. DMV clerks there enter that number if applicants don't provide another one. In the

early 2000s, North Carolina's license security issues were so bad that Florida—generally considered the second-most lax state in the U.S.—denied reciprocity to North Carolina license holders.

In the summer of 2002, New Jersey's DMV announced reforms, from heightened security at motor vehicle offices to better-trained employees to the design of more **tamper-resistant driver's licenses**. But the agency's existing security problems, which officials outlined along with proposed improvements, illustrated the enormous challenge suddenly facing agencies that many states have overlooked and underfunded for decades.

> **New Jersey was one of the last states without a digitized photograph on its license; in fact, as recently as late 2002, New Jersey drivers could opt to have no photograph at all. In short, New Jersey licenses were easy to forge.**

Security at motor vehicle offices around New Jersey ranged from spotty to minimal, giving criminals relatively easy access to driver's license **production equipment**, title certificates and other documents that were "the key components in crimes such as identity theft and insurance fraud," according to a report released by DMV officials. A state police assessment had found "numerous security failures, [including] easy access to valuable documents through open and unlocked doors as well as non-secure storage areas."

The 2002 reforms were meant to change all of that. Detailed background checks of agency employees by the state police had led to some firings and many more voluntary resignations. During that summer, 27 workers were fired for suspected fraud and other transgressions.

Among other steps the New Jersey DMV was taking:

- Requiring all license applicants to supply more than one form of identification.

- Planning the purchase of ultraviolet lights and illuminated magnifiers for each office to help in the detection of counterfeit documents.

- Seeking new or increased fees to pay for upgraded security.

In September 2002, for the second time that year, thieves broke into a driver's license office in Naples, Florida. They only got a half-used roll of film. In February, the crooks had been more successful, making off with 5,500 blank cards that could be made into high-quality fake licenses.

The break-ins seemed part of a larger scheme. About the same time as the second break-in, thieves had broken into a state office a couple hours to the north of Naples and stolen a computer that included graphics used in Florida driver's licenses. And, within a few days of *that* theft, a license camera had been stolen from a state office near Miami.

Throughout Florida, low-end fake licenses sell for $50 to $100; but high-end fakes, like ones made with stolen state equipment, could sell for as much as $1,000.

During the summer of 2002, hundreds of Colorado residents were advised to watch their credit after burglars made off with driver's licenses and personal information in two separate burglaries at state DMV offices. The break-ins, which took place a week apart, occurred at DMV offices in suburban locations outside of Denver. Investigators suspected that the crimes had been committed by the same people.

In the first break-in, the thieves escaped undetected with nearly 300 **expired driver's licenses**, which had been turned in for renewals, and $40,000 worth of equipment, including a machine that records fingerprints and signatures and prints licenses.

In the second break-in, the thieves stole about 420 expired licenses—as well as a smaller amount of computer equipment and forms that license applicants filled out verifying their personal information.

In the weeks after the break-ins, the Colorado DMV installed enhanced security systems at its busiest offices; and department officials began phasing in a centralized program for licensing. Under that program, isolated motor vehicles offices would stop printing licenses on site; information would be sent to a centralized printing facility and licenses mailed to applicants' homes. Also, the DMV distributed **new stamp-**

ing tools that allowed clerks to punch the word "void" into old licenses.

In October—about two months after the suburban break-ins—Deputy Colorado Attorney General Don Quick announced that his office had indicted a suspect. Glenn Allen Wilhite faced nine felony counts of burglary, theft, **theft by receiving, forgery and conspiracy** in the burglaries of the DMV offices.

Most of the stolen equipment and expired IDs had been recovered in a search of Wilhite's Denver home. According to the indictment, Wilhite had broken into the two DMV offices and used the stolen items to make counterfeit driver's licenses. He then sold the fake IDs to other crooks who used them to forge checks and for other illicit purposes.

"BREEDER" DOCUMENTS

All states require applicants to provide proof of identity but the AAMVA estimates that as many as 200 forms are accepted as this proof. Some of these so-called "breeder documents" are easy to fake.

Most states distinguish between primary IDs—in which they have a high degree of confidence—and secondary IDs. Common **primary IDs** include:

- a U.S. birth certificate;
- a current license from another state;
- a valid U.S. passport;
- military identification;
- an INS-issued "green card" that confers permanent residency status; and

- an **I-94 form** that indicates a visa holder's period of stay.

Secondary ID sources cover a wide range of documents, including:

- a Social Security card;
- a credit card with signature;
- an employer identification card;
- a foreign driver's license; and
- a baptismal certificate or family Bible record.

Most of the secondary IDs can be faked fairly easily, so they are usually accepted only as support of at least one primary ID. That's why ID thieves concentrate on developing high-quality documents from the primary list. **Birth certificates** are, in most cases, the easiest of those to fake.

Birth certificate fraud usually occurs in one of three forms:

- a counterfeit certificate is created;
- an original certificate itself is altered; or
- a duplicate certificate is obtained by an imposter.

> The main security problem posed by birth certificates is that so many agencies issue them. In addition to state registrars in the U.S., there are about 7,000 local registrars issuing certified copies of birth certificates.

Requests for certified copies of birth certificates are handled either in person or by mail, the latter offering more opportunity for fraud. Someone seeking a new identity can read a newspaper's obituary section, get the name and birth date of someone of similar age and request a certified copy of that person's birth certificate.

State and local registrars are required by law to make **birth and death records public**. This has typically meant providing access to the physical records at government offices. However, throughout the 1990s, many local government agencies started posting public records online. *This* meant the records could be obtained by anyone with an Internet connection.

Most states' vital record offices use unique paper and markings, seals and other features to deter alteration or counterfeiting of birth certificates. But these controls have not been put in place by many of the 7,000-odd local registrars. And, as of 2003, there was no mandated standard form for certified copies of birth certificates and no mandated national standard for issuance of birth certificates. The result: A **confusing variety of vital records**.

The U.S. Commission on Immigration Reform has recommended a series of actions to reduce fraudulent access to birth certificates, including:

- Regulating requests for birth certificates through standardized application forms;

- Using a standard design and paper stock for certified copies of birth certificates;

- Making certified copies of birth certificates issued by states or state-controlled vital records offices the only forms accepted by federal agencies (not certificates issued by local registrars);

- Encouraging states to computerize birth records repositories; and

- Creating a computerized system to match interstate and intrastate birth and death records.

The August 2002 arrest of a former clerk at the Texas Department of Health illustrates why these reforms are important.

Texas law enforcement officials charged Ana Laura Vasquez—a customer service representative at the state's Bureau of Vital Statistics—with tampering with government records, abuse of official capacity and forgery of a government instrument. They claimed that Vasquez **manipulated a state computer database** to produce at least 74 fake birth certificates that sold for as much as $6,000 each.

Investigators alleged that Vasquez was part of a criminal ring that sold certificates in Austin, Laredo, Corpus Christi and other cities in central and south Texas. According to the charges, Vasquez used office computers to pull up authentic birth certificates and alter them.

The computers in the Department of Health's customer service area were assigned to specific clerks but were not protected by passwords—so all clerks

> had access to all terminals. A video camera recorded Vasquez moving from one clerk's terminal to another, making her fake birth certificates in a way that would be difficult for computer system administrators to detect.

According to the investigators, Vasquez worked with at least one **accomplice** (a man married to her cousin). The accomplice would request birth certificates from various Departments of Health offices, giving Vasquez an excuse for generating her altered documents.

Vasquez was ultimately undone not by her own forgeries—but by someone else's shoddy work. One of her customers was a man who assembled various fake documents so that his daughter could get a Texas driver's license. The clerk reviewing the documents thought that the daughter's Social Security card **looked fake**; the clerk told the man and his daughter that their documents would have to be reviewed by a supervisor.

After the man left, the clerk tried to verify the Social Security card but couldn't get a timely response. So, instead, she checked with the state **Bureau of Vital Statistics** and got a response that conflicted with the rest of the daughter's personal information. An audit of the Bureau of Vital Statistics system using the birth record number pulled up information for another woman. And the certificate number pointed back to Vasquez's office.

After Vasquez was arrested, the Health Department said that it had increased security to assure that birth

certificates wouldn't be so easy to alter. But its spokes-woman declined to provide details.

NATIONAL ID CARD

The reforms suggested by groups like the Social Security Administration, the American Motor Vehicle Administrators Association and various local law enforcement agencies seem to lead to a common solution to these various ID problems: A **national identification card**, separate from a Social Security card or driver's license.

> **Proponents of a national ID card—Oracle Corp. CEO Lawrence Ellison is an outspoken one—use the 9/11 terrorist attacks to argue for standardized IDs that would contain data ranging from complete medical histories to shopping preferences.**

The proponents argue that the national ID should be a so-called "smart card." Smart cards are rapidly becoming popular in Europe, Latin America, Asia and Africa—regions plagued by rampant ID theft and high fraud losses. The smart card addresses this problem with an embedded computer chip, which gives it multi-use capability (it can be coded for telephone, ATM and other electronic uses) while simultaneously improving protection against identity theft and card counterfeiting. It can do this by containing encoded biometric data.

Immediately after 9/11, a Pew Research Center poll found that 70 percent of those surveyed favored such

a card. But this wasn't only reaction to the terrorist attacks. Gallup Polls taken in 1983, 1993 and 1995 had also shown that a majority of Americans favored a national ID. When demographic subcategories were indicated, **immigrants favored the card** at a higher rate than native-born Americans.

Efforts to create a national ID—usually by combining state driver's licenses systems into one national database—are not new. When Congress passed the Illegal Immigration Reform and Immigrant Responsibility Act of 1996, a provision was included requiring driver's licenses to contain a Social Security number that could be read visually or electronically. By requiring the use of the SSN, the federal government was instituting the Social Security number as a national identification number. After much outrage from civil libertarians, the SSN/National ID provision was repealed in 1999.

But 9/11 has tilted opinion more heavily in favor of some form of national ID.

Alan Dershowitz, a Harvard Law School professor and one of America's most outspoken civil libertarians, wrote a much-quoted column in *The New York Times* saying that **anonymity is not a freedom** guaranteed by the Constitution. He argued that fears of government intrusion could be allayed by clearly delineating the criteria under which a national identity card could be requested.

But the mere hint of national ID cards remains a big problem for some **civil libertarians**. For example, Edmund Mierzwinski of the U.S. Public Interest Research Group has said:

> While we are sensitive to the critical need for federal and state governments to take action to respond and prevent future outbreaks of terrorism, we do not believe that national ID and driver's-license policy solutions proposed as a result of 9/11 will help stop identity theft.

Mierzwinski and his liberal organization found a strange bedfellow in Lori Waters, executive director of the conservative Eagle Forum. In September 2002 congressional testimony, Waters said:

> Driver's license standardization is the national ID wolf in sheep's clothing. No member of Congress has introduced legislation entitled, "The National ID Card Act of 2002." The House did the right thing by including specific language in the Homeland Security Act of 2002 to ensure that nothing in the bill could be construed to authorize a national identification system or card. However, the fact is that a national ID system will more likely happen through a bureaucratic backdoor, an appropriations rider, conference report language or a bill with a supposedly different but noble cause.

Waters claimed that the Driver's License Modernization Act of 2002 was one such bill. It essentially would turn a driver's license into a smart card, connecting the various aspects of anyone's life. It required driver's licenses to **contain a computer chip** capable of containing all the text written on the card, encoded biometric data and—in some cases—data from nongovernmental sources. Most strikingly, it established the framework for a national ID: a unique identifier through biometrics and database linkage.

Once government and private industry databases are **interoperable through a unique identifier**, access to and uses of sensitive personal information would expand, insists Waters. Law enforcement, tax collectors and other government agencies would want access to the data. Landlords, insurers, credit agencies, mortgage brokers, direct mailers, private investigators, civil litigants and a long list of other private parties would likely require the new smart card ID—just as they have with the SSN.

Some proponents of a national ID openly admit that this broader use would follow. In AAMVA's *Customer Focus White Paper* on the topic, the group's member DMV administrators are mentioned as only one of almost 20 "user communities" of a proposed national ID card. Other users include law enforcement, government agencies at the federal, state and local level, restaurants and bars, employers, insurance providers, the health care industry, airlines, building and facility security, storeowners, schools, the retail industry generally and even the gaming industry. And, the national ID would be used for **functions beyond simply establishing identity**. For example, AAMVA suggests that many of these users would be able to gather and record demographic information to create mailing and marketing lists, purchase histories, etc., or use the ID for personal banking and securing online transactions.

The most compelling argument against the idea gets back to the basics of identity theft. What happens, under a national ID system, when your card is stolen? Will it be any easier to remedy ID theft? Enhancing the value of these documents will only make it more

lucrative to sell IDs (or even whole databases of information) under the table.

What would happen if an ID card had your name on it, but someone else's biometric identifier? If the system depends on a thumbprint, how do you reclaim your identity once the digital version of your thumbprint has been spread across the Internet? An identification system is only as "smart" as the information that establishes identity in the first place. **Standardizing state driver's licenses**, suggest ID theft experts, would cement false identities onto national ID cards.

> **Most ID theft experts worry that smart crooks are just as crafty as smart cards. There are always ways to beat the system.**

One German magazine tested several different types of biometrics, including facial recognition, fingerprint devices and iris scans, and was able to circumvent all of them. The fingerprint scanner was outsmarted by some adhesive film (similar to scotch tape) and resin; the iris scan was fooled by a photo image of one person's iris held in front of another's person's eye. Using **ordinary kitchen supplies**, a Japanese researcher was able to fool a fingerprint detector about 80 percent of the time. And, back in the U.S., several researchers defeated smart card technology using a camera flashgun and microscope to extract secret information widely used in smart cards.

CONCLUSION

SSNs and state driver's licenses are **chaotically administered** and easy to fake. Nationalizing the American ID system gives many people Orwellian jitters. And smart card technology can be bested by smarter crooks. So, what's the answer to the ID card question?

Like so many answers: Common sense and some incremental reforms.

Congress should work with state governments, including state legislatures, to provide DMV employees with necessary tools and training on renewal and issuance of state driver's licenses and to assist with anti-fraud programs. For example:

- Any errors in replacement requests for driver's licenses and state ID cards, such as misspelling of the applicant's name or street name, should be considered a significant reason to flag an application for further evaluation.

- All DMV employees that deal with the issuance and renewal of identifying documents should receive comprehensive and ongoing training.

- Requests for duplicate or replacement driver's licenses or ID cards should only be presented in person, not by phone or the Internet.

- A testing program should be employed to identify fraud and abuse within the DMV's systems and to verify that procedures are being followed.

States could greatly improve the security of driver's licenses by adopting **common sense procedures**, such as:

- Improving the identification verification process by establishing designated licensing offices where employees would be trained to spot fraudulent documents and be equipped with the computer equipment necessary to check databases maintained by the SSA and INS. Non-permanent resident immigrants and visa holders would be required to use one of these offices.

- Eliminating some types of documentation that can be easily forged or abused, such as the I-94 visa form and the IRS taxpayer identification number.

- Stopping the common practice of issuing licenses to foreign nationals on a same-day basis, which makes it extremely difficult to properly check identity and residency documents.

- Tying license expirations to those indicated on visas and foreign passports instead of automatically granting the typical four-to-six year expiration period.

- Restricting the number of duplicated licenses issued to one individual to replace stolen or lost originals.

- Requiring that photo identification be shown at every stage of the licensing process and refusing to permit photographs that obscure individuals' faces.

- Increasing the penalties for obtaining a license through fraudulent means.

What can you do to secure your SSN and driver's license? Keep your Social Security card out of your wallet or purse and in a safe place at home. Keep your SSN **in your head**—and only give it to companies that really need it. This will be reiterated throughout this book.

You have to keep your driver's license on your person…and you probably need a state-issued photo ID even if you don't drive. The best advice here: Try not to lose it.

4

THE MECHANICS OF
ID THEFT

So, we've covered what identity theft is. And *who's* most likely to commit it. And how the nature of many identification systems enables the thieves. In this chapter, we consider the question of precisely *how* identity thieves commit their crimes.

Because ID systems are so varied, there are many ways for crooks to commit identity theft. Low-tech thieves can dig up personal financial information by going through **commercial and residential trash**. More ambitious—or less patient—thieves can steal mail from mailboxes. Others look for **low-risk opportunities** to pick up an inattentive person's wallet or purse.

Identity thieves tend to be more creative than daring. Few want to face the risks of stealing information at knife-point. They'd much prefer to take a job as a janitor in an office building or bribe a letter carrier to hunt for credit card bills or other information.

And then there's the Internet. With the proliferation of computers and increased use of the World Wide Web, identity thieves have used information obtained from **company databases** and Web sites. In some cases, the information obtained is in the public domain; in others, it is proprietary—and is gotten by means of a computer intrusion.

In this chapter, we'll consider the most common mechanics of ID theft.

STEALING CHECKS

Mechanically, the easiest way to steal someone's identity is to get his or her personal checks. Even if the check is all a crook has, it can be enough.

In the summer of 2002, an Arkansas man stole several people's identities by using information on personal checks he took from a **small business's cash box**. Local law enforcement authorities were concerned because he was able to make so much financial mayhem with nothing more than the checks.

The cash box was stolen from Quality Door & Screen in North Little Rock in April. About two months later, different state revenue offices issued three separate identification cards bearing the same picture. The thief forged forms of identification—including out-of-state driver's licenses and birth certificates—and used those to get Arkansas state IDs. The names and addresses on the IDs matched those of people whose **checks had been in the cash box**. And the crook got them without having Social Security numbers or other critical information.

Next, he used the state ID cards to make small deposits into bank accounts belonging to the three central Arkansas men whose checks had been in the cash box. Finally, over several days, he withdrew everything from the accounts. In total, he made away with more than $10,000.

North Little Rock police were left with a picture…but no name or other information…of the ID thief.

That same summer, an Oregon woman accused of using stolen checks and fake identities to purchase at least $150,000 in merchandise from Portland-area retailers was arrested. Catherine Gail Hoy-Nelson was caught driving a $35,000 Mitsubishi Eclipse convertible that had been reported stolen because it was **purchased with a bad check and a stolen identity**. A printout of a local police department's Internet Web page—with Hoy-Nelson's picture featured in a most-wanted section—was in the car.

In the days after her arrest, police recovered about $25,000 in merchandise purchased with stolen checks from retailers such as Home Depot and Leather Express.

Police had been looking for Hoy-Nelson for more than a year. They'd tracked her at different times to various Portland-area addresses…but had not been able to locate her. Her *modus operandi* had been to **prowl wealthy neighborhoods**, looking for packages of new checks to steal from unlocked mailboxes. After she got the checks, she'd create an identity for herself around them.

But Hoy-Nelson didn't operate entirely alone; local police said that she'd worked with various people to sell the ill-gotten merchandise or trade it for drugs.

STEAL THE WHOLE MAILBOX

Since local law enforcement—and even many individuals—have gotten wise about protecting checks in unsecured personal mailboxes, some crooks have gotten more aggressive about what they steal. In late August 2002, thieves took a U.S. Postal Service mailbox in San Diego—making it the fourth stolen in three months. All of the mailboxes were removed by being **unbolted from the ground**; all were eventually found, empty. The crooks seemed to be working methodically. The mailbox heists took place about every 30 days, in different parts of San Diego County.

And there was no doubt what the crooks were looking for. A retired schoolteacher who'd lost mail in one of the boxes reported ID theft to local police. Someone had altered checks included with two of her bills and cashed them—taking $1,300 from her checking account. Separately, someone had applied for a credit card in her husband's name.

In September 2002—a continent away from San Diego—a crew of thieves broke **open mailboxes at post offices** in several suburban communities south of Tampa, Florida. The selected post offices were in neighborhoods considered **safe, middle-class (not wealthy) communities** with many retirees.

The crooks seemed to have prepared for their heists and cased the post offices in advance. Their *modus operandi* was to wait until dark, then approach collec-

tion boxes outside of the targeted post offices. They'd used heavy hand-tools (apparently custom-built for the work) to pry open the back doors of the collection boxes and steal all of the mail inside. A witness to one of the thefts said the crooks were a group of four, apparently three men and a woman. They worked very quickly and seemed to be **well-rehearsed**.

The crooks also seemed to be careful to keep their schedule unpredictable. Two of the mailbox heists took place a few days apart; the others more than a week apart. The local police said this made it unlikely that the thieves were mischievous teenagers or desperate junkies. One officer said the crew was "careful" and "definitely not stupid." The irregular schedule made it harder for police to anticipate their moves.

Investigators with the local sheriff's office said that, though the crooks took everything from the mailboxes, the careful preparations pointed to ID theft as the motive. The crooks were probably **looking for mortgage and credit card payments**—which would include account information and checks.

CREDIT CARD SKIMMING

Skimming occurs when the **data on the magnetic strip** on the back of a credit or ATM card is captured by swiping the card through a device that resembles, in most cases, a pager or small cell phone.

The information from the magnetic strip is stored in the device until its memory fills up or until it is downloaded to a computer or transferred onto the magnetic strip of blank cards. (The blank cards that have the copied data are called *cloned cards*.)

The restaurant industry is particularly vulnerable to skimming because it is one of the few retail sectors where, for a few moments, customers are separated from their credit cards and often can't see their servers processing payment authorizations. Because most skimming devices are small enough to fit unseen in an adult's hand, an **unscrupulous waiter, bartender or cashier** can easily swipe a card without being seen.

Skimming first caught the attention of law enforcement agencies in the mid-1990s, when e-commerce and other types of electronic transactions started to become popular. In the classic model, crooks skim credit cards at restaurants or other retail stores and then use to the card information to make online purchases—usually within 24 hours of the skim.

> Credit card companies don't like talking about how much money is stolen through skimming; apparently, they believe that discussing the phenomenon will only encourage more of it. But informed sources in the industry estimate that the major card companies lose as much as $300 million a year in the U.S. due to skimming.

The crooks that specialize in skimming usually **work with restaurant or retail employees** who consider themselves underpaid. The crooks offer $20 to $50 per swiped card. The employees take the devices with them—as we mentioned, the things can be easily mistaken for a pager or cell phone—and swipe as many cards as time and circumstances allow.

Smart crooks will circulate through a metropolitan area, not spending more than a day or so skimming in any single location. In fact, according to one Florida law enforcement official, the most efficient crooks will spend two or three times as many hours finding promising locations and corruptible waiters or bartenders as they will actually skimming.

Experts say that 70 percent of all skimming takes place in restaurants or bars. But that doesn't mean *all* skimming takes place there.

In July 2002, Benjamin Driscoll—a resident of Delray Beach, Florida (north of Miami) discovered a **skimming scheme** at a local Bank of America branch. When Driscoll swiped his ATM card and entered his PIN at one of the branch's cash machines, a message appeared on the screen stating that his transaction could not be processed.

Driscoll swiped his card again but grew suspicious and tugged on the machine. A skimming device, which had been **attached with Velcro over the ATM**'s normal card slot, came off into his hands.

A spokesman for Bank of America admitted that Driscoll's experience was not unique…that a number of aggressive ID thieves attach skimming devices to ATMs. In most cases, the spokesman said, the thieves will also attach professional-looking signs to the machines saying there is something wrong with the ATM and instructing people to use the alternate swipe.

The main drawback to skimming—from the crook's perspective—is that it's a short-lived scheme. Skimmers usually have to make all of their purchases and transactions before the true card owner gets his or her next monthly statement. Sometimes the crook can find out when the statements are mailed; but, more often, they don't want to risk discovery by asking.

In short, the card skimmer—and most ID thieves, no matter what their *modus operandi*—run so-called **bust-out schemes**. In purest form of these schemes, the crooks use credit card terminals obtained by a shell or front business to apply charges to stolen credit cards. The crooks run the cards or numbers through the terminals but do not provide any goods or services. The credit card company credits the account of the front business. Before the next statement from the stolen card reaches its rightful owner and the bogus charges can be reversed, the funds are moved out of the front business account.

> In a slight variation on this scheme, the crook will use the stolen cards (or card information) to buy things from legitimate businesses—and flee with the goods before the next statement arrives.

Some seasoned ID thieves move from city to city, skimming card information, charging up goods and either busting out or moving on.

INSIDERS STEALING IDENTITIES

Skimming often relies on the **cooperation of corruptible employees**. But it's a relatively simple and often anonymous proposition.

More complex ID thefts involve more detailed cooperation between employees and thieves. At a meeting of Florida law enforcement officials in November 2002, lawyers with the state attorney's office introduced a veteran ID thief for some dramatic testimony. Wearing a plastic mask that reminded some of the Hannibal Lecter character from the film *Silence of the Lambs*, the speaker offered details on how he'd been able to steal between $15 million and $20 million using other people's names.

He claimed that he could purchase a Florida driver's license for as little as $100 and, in a few minutes of telephone work, he could get someone's Social Security number—all with the help of "people on the inside." In all, he'd corrupted more than 50 people working in the offices of state and federal agencies in various Florida cities; and he'd been able to do it all by focusing on clerical and administrative employees. Not managers or professionals.

He said **greedy people** were happy to sell him other people's personal identification. He would pay as much as $1,000 for a complete package—that included a name, birth date, address, account details and SSN. He pointed out that the most effective ID thieves prefer not to steal credit cards, because owners miss them quickly and report their loss. It is easier, he said, to corrupt a bank worker, a driver's-license examiner or someone from a credit-reporting service.

ID thieves often use techniques similar to drug dealers. A group of middlemen will contact corruptible employees; these middlemen function as independent contractors with a penchant for secrecy.

The crooks often contact employees on the recommendation of a mutual acquaintance, keep communications limited to a cell phone and stay in one place for a short time. They **pay cash for credit card numbers**, bank account information, blank document forms and—most importantly—Social Security numbers.

In May 2002, Ford Motor Credit Company (which writes mortgages, as well as car loans) sent out a series of letters notifying some 13,000 borrowers that their credit information may have been stolen. For more than a year, a crew of sophisticated ID thieves had been breaking into the files at credit bureau Experian, using a Ford Motor Credit password and lender account information.

Experian blamed the breach on the Ford account information. For its part, Ford spokespeople said they didn't know how the break-ins happened—and they couldn't rule out employee involvement. Rich Van Leeuwen, a Ford Motor Credit executive, said:

> A lot of these attacks happen because of insiders that have particular knowledge of how the application works, or get help from somebody from the inside without even knowing that they're helping the attack happen.

The ID thieves accessing the Ford Motor Credit data were looking for more than just credit card numbers. The credit information that Ford kept in the Experian system included complete identities—SSNs, birth dates, family names, bank information—that crooks could use to establish complete financial clones of the borrowers. In law enforcement circles, this more complete reproduction is called *true identity theft*. And it can go on for years without being stopped.

About the same time as the Ford Motor Credit debacle, a Philadelphia-based ID theft scheme that used a corrupted insider was coming to light.

More than 40 people who banked with the Philadelphia Federal Credit Union started finding out that their credit histories had been stolen. The ID theft had enabled local crooks to operate a huge bust-out scheme; they bought more than 60 new or late-model cars worth almost $2 million from Philadelphia-area dealers, using the Credit Union customers' credit. The crooks **sold or moved the cars**; and they never made any payments.

But the ID heist had been too dramatic to go unnoticed. Because the crooks had used so many IDs stolen from one financial institution, federal banking authorities were able to trace the dirty deals back to a single source. The Feds' detective work led them to a Philadelphia Federal Credit Union employee—a part-time clerk named Marpessa McNeil.

> McNeil hardly seemed like a hardened criminal. She was a recent college graduate (with a degree in

criminal justice, no less) in her mid-20s, who'd been working for the Credit Union for several years to strong performance reviews. But she'd been influenced by a hard character.

Darryl Brown, who had a checkered history of financial missteps, misdemeanors and malfeasance, had paid McNeil $10,000 for getting the detailed credit reports of 44 Credit Union members. He had coordinated the automobile bust-out scheme.

Brown, McNeil and several others were found guilty of various crimes including identity theft and grand larceny.

The victims of the scheme seemed more upset with McNeil—whom they'd trusted—than the con artist Brown. Credit Union members and executives petitioned the federal judge hearing the case to make an example of McNeil. And he did.

U.S. District Judge John R. Padova sentenced McNeil to 30 months in prison and ordered her to pay back $674,661. The sentence exceeded standard guidelines; but Padova defended his decision because of "the severe non-economic harm" the Credit Union members had suffered in piecing back together their damaged credit.

Some ID thieves don't like to rely on bribed insiders for credit information. They are more patient—and systematic. And they take customer service jobs themselves to get access to the information.

In August 2002, Kansas law enforcement agents charged a former customer service manager at several local companies with stealing identities from people who paid their bills with credit cards. Christopher Paul Ware was charged with five counts of identity theft.

Local detectives said Ware **took customer-service jobs** at Verizon Wireless, Capital One, Chrysler Finance and Household Payroll Services, all in the Kansas City area. He kept a private log of names, Social Security numbers, mothers' maiden names and other information when customers called him to pay their bills. He might have gotten away with the thefts—but he stayed in the Kansas City area too long.

Local police tracked Ware down only after he'd used two fraudulent credit cards and a false credit application to buy a car. They arrested him at his office in the suburban town of Overland Park—and found more than a dozen files of customer identity information in a bag he carried.

WI-FI AND OTHER WEB RISKS

Identity theft is a disturbing combination of old schemes and abuse of emerging technologies.

One example of such abuse of new technologies is called *wardriving*—randomly searching for open signals to acquire free wireless Internet service.

Proponents of the practice envision a **utopian Internet world** where everybody can walk outside and log on without paying a provider. But the signals can also be used to gain access to private information

in the computers of the companies that pay for the service. No passwords or secret codes have to be cracked using this method.

Entering computer systems without official permission is a state and federal crime. Penalties depend on the amount of damage that results. But it remains a popular activity among the hacker community. Some wardrivers invade computer networks for fun; others do it for identity theft, password acquisition or just plain old snooping.

A wardriver can use ordinary equipment—such as a simple laptop computer, a commonly-available antenna and the Windows 2000 operating system. The only difficult part is getting the right software; but even that is done easily enough on the Internet. One popular program, called *netstumbler*, recognizes signal access points in a small geographic area.

Online ID theft exposures don't require anarchistic hackers.

Some thieves gain access to your personal information via old e-mail—that you thought you'd deleted. E-mail services often make backup copies of the e-mail so as to recover from a catastrophic failure of a primary server. From time to time, e-mail users are surprised to discover that e-mail they thought they had long since deleted has been **retained in backup files** and has been released by accident or has become discoverable in a legal proceeding or is accessible under appropriate warrants.

Other thieves gain access to personal information through another serious consumer Internet risk that arises from **access-controlled services** requiring user authentication. The most common method of authentication is to associate a password with a user identifier (ID). These passwords are often fixed and reused repeatedly. Users are notorious for the poor choices of passwords and their unwillingness to change them regularly. Passwords can often be guessed (birthdate, pet's name, spouse's name, the current year, anniversary date, Social Security number, telephone number, address).

Password files at the service hosts are usually one-way encrypted but if a hacker can get a copy of the encrypted password file it's possible to run a "reverse dictionary attack" to try to find the password. In a reverse dictionary attack, all the words in the dictionary are encrypted and then compared with each of the encrypted passwords taken from the target computer. A match exposes the password. Such tools are very commonly available.

Good password practices dictate at the least that reusable passwords be changed regularly, contain more than just alphabetic characters, be six to 10 characters long and not contain common words found in the dictionary. See Chapter 8 for more about passwords.

Information about **consumer use of Web services** can be collected in each user's personal computer by Web service providers in small caches of information called "cookies." The Web service providers can

use this information to tailor services provided to individual users. Consumers are at risk if companies that collect this data make use of it in ways that consumers do not expect or would not approve. It is this concern that led to requirements for companies to report their privacy protection practices to consumers on a regular basis.

Not all Web sites are what they seem. Some may appear to offer products or services but may in fact simply be "fronts" for purposes of **capturing personal information**, credit card numbers and the like. This is outright fraud.

Finally, software can be put into your computer by someone with physical access to it that will provide a record of virtually everything you do with your machine. Similar software might be ingested over the Internet as an attachment to an e-mail message or possibly as a consequence of loading a Web page and executing "applets." Such "**Trojan horse**" software can expose all of your personal computer's data and activity to view.

SLOPPY ONLINE SHOPPING HABITS

People who use the Internet today willingly give up a lot of information about themselves.

In this age of gathering marketing data, information and cross-referencing databases, once you purchase something online and they have a good profile of you, that information can be propagated to a lot of other agencies or places and sold.

Your credit card information is stored at that company. And security of your information is only as good as the security of the company that's storing your information. If they've broken into it and your information is sold or stolen, you've got no control. Once it's gone, it's gone.

If you buy something online, the company that sold you that something may have the right—even the *obligation*—to **give the information to other entities**—including the federal government, for one. And, if there's a financial transaction involved, the online company may have obligations to give the information to affiliates and reporting services. And they may want to give the information to marketers.

(Of course, this isn't a phenomenon that's limited to the Internet. Often, when you buy things in bricks-and-mortar stores, there's more **information-sharing** going on than you ever realize.)

Not all online information sharing is bad. Some goes to positive use: Companies take information of your purchases and create a profile and then develop **customized pitches to your needs and wants**. Many people like those campaigns.

On the other hand, when it's shared and sliced and diced by people you don't know and you don't understand how they're going to use it, it's very discomforting.

> **The thing to remember is that Internet security is oriented toward convenience, not protecting the information.**

In his May 2001 congressional testimony, Bruce Townsend, Special Agent in Charge of Financial Crimes Division, United States Secret Service, said:

> Information collection has become a common byproduct of the newly emerging e-commerce. Internet purchases, credit card sales and other forms of electronic transactions are being captured, stored and analyzed by entrepreneurs intent on increasing their market share. The result is a growing business sector for promoting the buying and selling of personal information.

With the advent of the Internet, companies have been created for the sole purpose of **data mining, data warehousing and brokering** of this information. These companies collect a wealth of information about consumers, including information as confidential as their medical histories.

The Internet provides the anonymity that criminals desire. In the past, fraud schemes required false identification documents, and necessitated a "face to face" exchange of information and identity verification. Now with just a laptop and a modem, criminals are capable of perpetrating a variety of financial crimes without identity documents through the use of stolen personal information.

In an investigation conducted in April 2001, Secret Service Agents from the Lexington, Kentucky, Resident Office, along with their local law enforcement

partners from the Richmond, Kentucky, Police Department, arrested a suspect who was operating an online auction selling **counterfeit sports memorabilia**. During this investigation, it was learned that the suspect had fraudulently opened a number of credit card accounts utilizing the personal information of individuals who had participated in his auction on the Internet.

FAKE IRS FORMS

In 2001 and 2002, a scheme appeared throughout the U.S. that used fictitious bank correspondence and bogus IRS forms to mislead taxpayers into disclosing their personal and banking data. The information was then used to steal the taxpayers' identities and bank account balances.

In the scam, the taxpayer receives a letter, purportedly from his or her bank, stating that the **bank is updating its records** to exempt the taxpayer from reporting interest or having tax withheld on interest paid on the taxpayer's bank accounts or other financial dealings. According to the letter, anyone who does not file an enclosed form is subject to 31 percent withholding on the interest paid.

The bank correspondence encloses a form allegedly from the IRS and seeks detailed financial and personal data. Recipients are urged to fax the completed forms within seven days. Once they get the information, the scheme's promoters use the information to **impersonate the taxpayer and gain access** to his or her finances.

One such form is labeled W-9095, Application Form for Certificate Status/Ownership for Withholding Tax. This form requests personal information frequently used to prove identity, including passport numbers and mothers' maiden names. It also asks for data such as bank account numbers, passwords and PIN numbers needed for access to the accounts.

> This form is meant to mimic the genuine Form W-9. However, the only personal information that a genuine W-9 requests is the taxpayer's name, address and Social Security number or employer identification number.

Other fictitious forms include **Form W-8BEN**. In contrast to the legitimate W-8BEN, the fictitious one has been altered to ask for personal information much like the W-9095. Also used is a form labeled **W-8888**.

The requested information in the fake form goes far beyond what anything anyone would wisely want to volunteer to strangers: a passport number, mother's maiden name, account numbers and names, dates they were opened and date of the last transaction.

> Legitimate IRS forms generally have an IRS processing center address on them as well as the IRS phone number. Beyond that, the IRS doesn't ask for things like your bank passwords or insist that you fax things in to them.

Any such request should be a red flag.

MEDICAL ID THEFT

Taking advantage of e-commerce and insufficient safeguards on patient and physician information in hospitals and clinics, crooks have come up with sophisticated schemes to **steal physician identities** and walk off with millions of dollars.

In California, an ID theft crew allegedly defrauded the state's Medicaid program of $3.9 million by using physicians' stolen identities to order bogus tests—and then billing both Medicare and Medicaid for the tests.

Identity theft is a particular problem for Medi-Cal, California's Medicaid program. Medicare is harder to defraud because the insurance forms go out to the recipients. But Medicaid doesn't send out notices of what claims are being submitted, so there's **no paper trail** to track down criminals.

> **Physician identities are accessible from sources such as a state medical board's Web site, local physician directories or the Yellow Pages.**

Physician names, as well as copies of medical licenses and office addresses, also can be stolen from hospital personnel files. The criminals submit the documents to the state health department to obtain Medicaid provider numbers and then tell the state Medicaid program that the physician has a new address and request payment at that address. If the physician

doesn't have a Medicaid provider number, crooks will use the stolen identities to file for one.

Another tactic involves stealing the names, Social Security numbers or identification numbers of Medicaid and Medicare beneficiaries. Both patient information and physician information are necessary to bill the programs.

Once armed with the physician's name and provider numbers, as well as stolen patient information, criminals can **submit bogus claims to Medicaid or Medicare**.

The reimbursement checks are either mailed to the clinics, labs or post office box addresses, or directly deposited to bank accounts opened under the physicians' stolen identities. The crooks then forge the physicians' signatures on the checks that the state sends them.

This type of fraud can go on for years, until the physician gets a call from the Internal Revenue Service, asking why she didn't pay taxes on $400,000 of income received from Medicaid. Neither Medicaid nor the physician knew what was going on.

In early August 2002, a claims entry operator for Wisconsin Physicians Service was charged with identity theft after he allegedly supplied personal information of WPS clients to a Milwaukee man who used it to apply for credit cards.

Mario L. Mason, who worked for WPS subsidiary Tricare health insurance, allegedly took names and personal data from claims he processed for Tricare

and gave them to Milwaukee resident Marques J. Kincaid, who used the information to fill out credit card applications on the Internet.

Mason and Kincaid were each charged with identity theft. According to a criminal complaint, they had become acquainted while serving time in the Dane County Jail several months earlier. Kincaid used the name and personal information of an Arlington, Texas, man to obtain a credit card that he used to obtain cash advances of more than $8,000.

Why Tricare didn't run a background check on Mason—the employee who had access to so much personal financial information—remained an unanswered question.

Federal law enforcement agencies are particularly aware of medical ID theft issues. The **Department of Health and Human Services**, cooperating with the FBI, uses a sophisticated **software data mining tool** to analyze all claims submitted by medical providers and pharmacies and compare them against member enrollment data and other information. Unusual billing practices are targeted for an in-depth audit or investigation.

Such schemes include: submitting altered medical bills; billing for services never received; doctor-shopping to obtain multiple prescriptions for controlled substances; and stealing a physician's pre-

> scriptions pad and submitting forged prescriptions
> for controlled substances to pharmacists.

The software data mining tool helped the FBI build a case against Richard J. Farina and his business, Pennsylvania-based Inner Health Lifestyle Center.

Farina and Inner Health each pled guilty to two federal felony counts of health care fraud for submitting fraudulent bills to the local Blue Cross and its subsidiary, Keystone Health Plan East. The bills claimed that Farina had provided patients with chiropractic services, when they actually had received weight loss and exercise treatments.

> The data mining software tool determined that Farina and his business had submitted claims that alleged he had rendered in excess of 49 hours of care to patients on a given day.

Following their federal indictment and subsequent plea agreement, Farina and Inner Health were ordered to pay $109,000 restitution to the local Blue Cross. Inner Health was ordered to stop doing business; Farina was sentenced to **six months home confinement**, five years probation and forced to surrender his New Jersey and Pennsylvania chiropractic licenses for 10 years.

Other medical ID theft takes a simpler—and more vulgar—form than complex insurance scams. For

example: In September 2002, the wife of a California optometrist was facing criminal charges of stealing credit card numbers from her husband's patient files and using them to order merchandise on the Internet.

Kim Yasuda, who did office work for her husband, had access to credit card numbers in the files of his patients. Authorities said she used credit card numbers belonging to three patients of her husband, Dr. Jerry Yasuda. She was charged with three counts of identity theft, two counts of grand theft and one count of computer fraud.

Visalia police reports said Kim Yasuda ordered merchandise in her victims' names over the Internet, then had the packages **delivered to the home of a neighbor who traveled a lot**. If the neighbor wasn't home when a package arrived, she would pick it up.

The items the woman ordered showed a depressingly banal taste in ill-gotten goods. They included women's and children's clothes, Disney videos, items from *Amazon.com* and items from *www.statelinetack.com*, an Internet site selling horse-riding apparel.

CONCLUSION

The mechanical details of ID theft change with circumstances, technology advances and the perverse creativity of crooks. But, in this chapter, we've dealt with the **basic building blocks** of most ID theft schemes:

- Improper and illegal use of checks and credit cards;

- **Inattentiveness of** the victims;

- Trusted or insider status of someone involved in the scheme;

- **Quick use** of the ill-gotten ID information;

- Smart ID thieves move around a lot;

- Bold ID thieves will contact banks and credit card companies to alter account information;

- ID thieves are aggressive about **using technology**;

- Internet and online merchants create exposure by emphasizing convenience;

- All merchants may share your information more than you realize; and

- **Medical information** is an overlooked exposure.

ILLEGAL IMMIGRATION, TERRORISM, DRUGS AND OTHER CRIMES

Identity theft has long been a side effect of other, more ambitious crimes. Dapper con men may use fake IDs; but so do violent gangbangers, sleazy drug dealers and hungry immigrants desperate for work.

In calendar year 2000, the Social Security Administration (SSA) issued approximately **1.2 million SSNs to non-citizens**. While SSNs issued to non-citizens represent only about 20 percent of the total, the volume is significant.

In 2002, the Census Bureau estimated that 8.7 million people resided in the United States illegally. The Immigration and Naturalization Service (INS) has estimated that approximately 40 percent of illegal immigrants are **visa overstayers** while 60 percent entered illegally. Although most illegal immigrants simply want better lives for their families and themselves, their presence has spawned widespread document and identity fraud throughout the U.S.

The immense demand for documents "proving" the right to work in the United States has led to the **ex-**

ploitation of loopholes in laws and regulations at every level of government.

In 1986, the U.S. Congress passed the Immigration Reform and Control Act (IRCA), a key element of which was sanctions against employers who hired illegal aliens. IRCA had the unintended consequence of accelerating the proliferation of counterfeit, stolen and illegally obtained Social Security cards and driver's licenses.

Undocumented immigrants and those with visas that don't permit employment have devised multiple ways to obtain a Social Security card fraudulently—they can:

- invent a SSN;

- steal or borrow a Social Security card;

- buy a counterfeit Social Security card;

- obtain a valid Social Security card by using false evidentiary documents, such as counterfeit passports and INS papers;

- obtain a valid Social Security card by using a fraudulently acquired U.S. birth certificate; or

- fraudulently obtain a valid replacement Social Security card by stealing a person's identity.

If illegal aliens invent SSNs, steal or borrow authentic cards or buy counterfeit ones, the SSA will not catch on without the aid of employers. But few employers seem inclined to cooperate.

The SSA's Employee Verification Service (EVS) is a mechanism for employers to match an individual's

name and SSN with SSA records. There were 6.5 million U.S. employers in fiscal year 2000. Only 6,000 employers were registered users, and of those, only 211 used EVS. Employers complain that the feedback is not timely.

> However a number of employers find the system to be *too* helpful, exposing the fact that their employees are in the country illegally or holding visas that do not permit them to work.

SSA statistics show three industries (agriculture, food and beverage and services) account for almost one-half of all wage items in SSA's Earnings Suspense File (ESF). The ESF is the Agency's record of annual wage reports submitted by employers for which employee names and SSNs fail to match the SSA's records. Of these industries, agriculture is the largest contributor, representing about 17 percent of all ESF items.

SSA has noted that about 55 percent of the items in the ESF have: 1) no name; 2) no name and no SSN; or 3) an unissued SSN. The remainder of the items in the ESF generally relates to a **mismatch between the name and SSN**.

ILLEGAL IMMIGRATION

The federal prosecution of Ousmane Sow and Aboubakar Doumbia for Social Security fraud illustrates how easily Social Security cards are obtained by fraud and what a large role this fraud plays in illegal immigration.

Sow and Doumbia were caught at Reagan National Airport in transit from New York to Miami. They were traveling on tickets paid for with stolen credit cards and were found to be carrying a dozen foreign passports and two dozen **stolen immigration forms**. Both men were charged with immigration fraud and pled guilty prior to trial. Interestingly, both had fraudulent Virginia identification cards even though they lived in New York.

One of the two men agreed to cooperate with the government and revealed the purpose of their trip to Miami. He informed investigators that he and his accomplice were part of a **West African criminal syndicate** (he used the term *crew*) based in New York City. This syndicate specialized in the fraudulent procurement of Social Security cards and, to a lesser extent, the fraudulent procurement of Virginia driver's licenses and identification cards. According to the cooperating defendant, members of the syndicate repeatedly traveled from New York to major cities in the United States on tickets paid for with stolen credit cards. The purpose of the trips was to apply for Social Security cards by fraud at the SSA offices in each city. At each office, the members of the syndicate would apply for a card using a passport and an INS form.

The members of the syndicate **altered the passports** by substituting their own photographs so that they could apply in person for a Social Security card in the name of one of the syndicate clients (to whom the passport actually belonged). They further placed doctored INS forms in the clients' passports to make it appear that they, the applicants, were lawfully in the United States and had the right to work. In fact, their

clients were illegal immigrants in New York and New Jersey who paid the syndicate between $700 and $1,500 for a Social Security card.

> According to the cooperating defendant, members of the syndicate had traveled to all of the major cities in the United States, often more than once, and obtained well over 1,000 fraudulent Social Security cards.

In July 2002, Social Security Administration Deputy Commissioner James B. Lockhart III told a U.S. Senate subcommittee that a new **electronic immigration verification process** was starting that month.

The lack of such a system had been a major criticism after 9/11, when officials initially thought terrorists had legally obtained Social Security numbers. The SSA could not verify visa status or other immigration documents for all non-citizens because no system was available to do so quickly.

The SSA was also implementing a system that assigned Social Security numbers to new immigrants when the State Department approves an immigrant visa at a foreign service post and the INS authorizes entry. The SSA wanted to make the numbers "less accessible to those with criminal intent as well as prevent individuals from using false or stolen birth records or immigration documents to obtain" them.

The federal prosecution of a Virginia notary public named Jennifer Wrenn illustrates how criminals pro-

duce false or **fictitious driver's licenses** for illegal immigrants.

Wrenn had offices in Falls Church and Manassas Park, Virginia, from which she ostensibly conducted the activities of her real estate business, Jenni Wrenn Realty. An investigation by the Virginia DMV, the INS and the IRS revealed, however, that the true work at both offices was the sale of fraudulent forms to immigrants seeking to obtain Virginia driver's licenses and identification cards.

Immigrants were coming to Wrenn through a network of paid drivers and middlemen with whom Wrenn worked. For a fee of between $500 and $1,000, these drivers and middlemen would bring immigrants from New Jersey, Connecticut, New York and other states to Wrenn offices. Once there, Wrenn and her staff would complete fraudulent forms for the immigrants. These fraudulent forms bore all the necessary signatures and affirmations—and falsely stated that the applicants were residents of Virginia. At the height of her business, Wrenn was providing fraudulent forms to over 1,000 immigrants a month.

Wrenn was arrested in February 2001, and subsequently convicted at trial of seven counts of conspiracy, identification document fraud, encouraging illegal immigration and money laundering. In addition, the government arrested and prosecuted a dozen other individuals who worked with her or for her on charges of **identification document fraud**. These individuals included a lawyer, notaries, drivers and other middlemen.

TERRORISM

Seven of the 9/11 hijackers used illegally obtained identification to **sneak past airport security**. The freedom with which these terrorists moved has been a considerable embarrassment to the U.S. government, with most of the criticism directed at the INS.

But the attacks of 9/11 also exposed cracks in the security system at the Social Security Administration. The relative ease with which the ID thieves-turned-terrorists manipulated the system called for tighter screenings and other security precautions.

When federal law enforcement agencies asked the SSA for assistance shortly after the attacks, time-consuming efforts ate up valuable hours as agents worked to obtain necessary authorization to see the files of suspects. Although the requests were expedited, it revealed a **weakness in a system** that prohibited the automatic disclosure of certain information to the Department of Justice or FBI in connection with a terrorist investigation.

> September 11th, 2001 focused government attention on the need to tighten security at the SSA and streamline cooperation among federal agencies to detect fraud and ferret it out.

Terrorists steal credit cards, passports and Social Security numbers, and use them to pay for their operations and create false identities, Dennis Lormel, chief of the FBI's financial crimes unit, told a Senate subcommittee in July 2002.

Lormel said 14 pending FBI terrorism investigations involved some form of identity theft.

"The methods used to finance terrorism range from the highly sophisticated to the most basic," Lormel said. He said an al-Qaida terrorist cell that was broken up in Madrid, Spain, used stolen credit cards in sales scams and for small purchases that did not require other identification. The group also used **fake passports to open bank accounts**, which were used to send money to and from countries such as Pakistan and Afghanistan.

Lormel told the senators that blank passports were stolen in Brussels, Belgium and were "finding their way into terrorist circles."

The 9/11 hijackers were able to open 35 U.S. bank accounts without having legitimate SSNs and opened some of the accounts with fabricated SSNs that were never checked or questioned by bank officials. The banks involved approved several account applications in which the hijackers simply filled in random numbers in spaces reserved for applicants' SSNs.

With no scrutiny from the financial institutions or government regulators, the hijackers were able to move hundreds of thousands of dollars from the Middle East into the United States through a **maze of bank accounts**, beginning more than a year before their attacks.

The hijackers relied most heavily on 14 accounts at Atlanta-based SunTrust Banks, moving $325,000 through accounts opened in Florida and taken out in the names of several of the hijackers.

Lormel went on to describe the steps that the FBI was taking to prevent other terrorists from having such success with ID theft within the U.S.:

> One involves targeting fraud schemes being committed by loosely organized groups to conduct criminal activity with a nexus to terrorist financing. The FBI has identified a number of such groups made up of members of varying ethnic backgrounds [that] are engaged in widespread fraud activity. Members of these groups may not themselves be terrorists, but proceeds from their criminal fraud schemes have directly or indirectly been used to fund terrorist activity and/or terrorist groups.

> Another initiative has been the development of a multi-phase data mining project that seeks to identify potential terrorist-related individuals through Social Security number misusage analysis.

According to Lormel, the threat is made more serious by the fact that terrorists have become **experts at identity theft and SSN fraud** to enable them to obtain cover employment and access to secure locations. There is virtually no means of obtaining identification that has not at some level been exploited by these groups, he said.

The data mining that Lormel mentioned has become a central part of the U.S. government's efforts to thwart ID thieves with terrorist connections. In earlier congressional testimony, Michael Chertoff—an Assistant U.S. Attorney General in charge of criminal prosecutions—had described the Justice Department's data mining activities. His description of data mining is a good one:

> We are using computers to analyze information obtained in the course of criminal investigations, to uncover patterns of behavior that, before the advent of such efficient technology, would have eluded us. Through what has come to be called "data mining" and predictive technology, we seek to identify other potential terrorists and terrorism financing networks. In our search for terrorists and terrorist cells, we are employing technology that was previously utilized primarily by the business community.

On May 2, 2002, the U.S. Attorney General announced a **nationwide sweep** of identity theft cases, in which 73 federal criminal prosecutions were brought against 135 individuals in 24 districts. In addition, to strengthen federal ID theft laws, the Attorney General announced that the Justice Department would seek legislation to enhance criminal penalties in identity theft-related cases.

Seven of the 9/11 hijackers—none of whom actually lived in the Commonwealth—had obtained Virginia driver's licenses by submitting false proof of Virginia residency.

In August 2002, law enforcement officials announced that a man whose name was used to wire money to

accused 9/11 conspirator Zacarias Moussaoui a year earlier was an American who appeared to have been a victim of identity theft.

Moussaoui's indictment charged that an accomplice, using the name Ahad Sabet, had wired $14,000 to Moussaoui in the United States, where he was pursuing flight training lessons. The allegation was one of the few connections in the indictment between Moussaoui and associates of the 9/11 hijackers.

The real Ahad Sabet apparently didn't know that his **missing passport** had made its way into the hands of terrorists until early 2002, when FBI agents contacted him in connection with the case against Moussaoui.

Moussaoui claimed the government had no case against him since its own evidence showed that Sabet and Ramzi bin al-Shibh—an alleged conspirator in the 9/11 attacks—were not the same person. But this argument raised questions about Moussaoui's **understanding of criminal procedure** (if not about his intelligence, generally). From the beginning, the government's claim had been that bin al-Shibh used Sabet as an alias to wire money to Moussaoui. An alias gathered through ID theft would fit the terrorists' needs nicely.

When investigators searched Moussaoui's possessions after the 9/11 attacks, they found a notebook listing bin al-Shibh's German phone number and the name "Ahad Sabet," according to the indictment. Crucial to the government's case was an explanation of how bin al-Shibh was able to obtain Sabet's identification papers while Sabet was living and working as a physician in the U.S.

Sabet's mother provided that answer: Her son's passport had been **stolen years earlier during a rock-climbing vacation** to Spain.

This explanation meshed with other information that government officials had about the 9/11 hijackers. Terrorist ringleader Mohammed Atta and bin al-Shibh (who remained at large two years after the attacks) had a history of meeting in Spain. Investigators in that country said both men flew to Spain in July 2001, on separate flights, apparently to review their plans for the 9/11 attacks.

According to Ahad Sabet's family, during his vacation to Spain, two or three young men approached his rented car as he sought directions—and then grabbed his backpack from the back seat and ran. Sabat's U.S. passport was inside the backpack.

> **Ahad Sabet's parents had come to the United States from Iran in the 1960s, according to family sources, and settled in the St. Louis area. Ahad Sabet was born there in 1972. His age and appearance was a perfect fit for a Yemeni terrorist looking for an American identity to steal.**

Other al-Qaida operatives detained by the U.S. government after the 9/11 attacks had extensive ties to American ID theft crews:

- Redouane Dahmani, a suspected al-Qaida associate of Algerian birth, purchased a new identity—including an

SSN—soon after he arrived in the U.S. He then filed a **false asylum application** under his own identity, using the INS documents that resulted in a "legitimate" SSN. Dahmani, who was living in the Phoenix area, was arrested in 2002 and charged by federal prosecutors with conspiracy regarding his asylum request. Local state prosecutors also charged him with forgery, perjury and identity theft. The local prosecutors accused him of attempting to acquire an Arizona driver's license using the name Abdel Halim Lalami and a French passport that was forged or contained false information.

- Sofiane Laimeche, another suspected al-Qaida associate, was smuggled into the United States on an Algerian ship through the port of Philadelphia, and—within five days—had made his way to Phoenix and purchased a new identity, including a SSN. He used the fake name, SSN and Immigration and Naturalization Service alien registration number when he filled out federal and state paperwork for a job in 1997. After his illegal entrance to the United States and false ID claims, Laimeche obtained a valid work visa. Laimeche was eventually charged with five counts of Social Security fraud and two counts of making false statements to the government.

In June 2002 testimony before the House Judiciary Committee, James G. Huse—Inspector General of

the Social Security Administration—described the **ID theft tools** used by the al-Qaida terrorists:

> We may never know with absolute certainty how many of the 19 hijackers of September 11th used improperly obtained SSNs, or how they obtained them. Following the September 11th attacks, the Office of the Inspector General (OIG) immediately received from the Federal Bureau of Investigation (FBI) the names and other personal identifiers (as they then knew them) of the 19 terrorist hijackers who died in these attacks. Those names and identifiers were matched against SSA's indices. We associated SSNs with 12 of the 19 names. Of the SSNs associated with these 12 names, five appeared to be counterfeit (SSNs that were never issued by SSA). In addition, one was associated with a child, leaving six names associated with SSNs that were issued by SSA. Further, four of these six names were associated with multiple SSNs.

Unfortunately, until 9/11, SSA had limited success encouraging the INS to move quickly on either of these planned initiatives, as the projects did not appear to be as high a priority to INS as they were to SSA. Huse has blamed the cracks in SSN security on bureaucratic turf battles between the certain parts of the SSA and the INS.

DRUGS

In July 2002, a two-month investigation that zeroed in on two suspected methamphetamine labs in the Livermore, California, area led to the arrest of at least six people on **drug and ID theft charges**.

Detectives had been told by informants that a man was producing methamphetamine at a ranch on the eastern outskirts of Livermore—a fairly remote section of the county. The same informants also mentioned a rival operation at a second ranch not far from the first. The detectives watched the properties for several weeks.

Once they'd established a reasonable case, Alameda County Sheriff's Office investigators **raided both ranches** on the same day. Armed with search warrants, the detectives seized guns, methamphetamine and some familiar evidence of ID theft: driver's licenses, credit cards and other personal documents belonging to residents of some of the county's wealthier neighborhoods.

The second ranch had more ID theft evidence. In a trailer parked on that property, investigators found a cache of fake California driver's licenses and fraudulently obtained credit cards and hundreds of personal checks and Social Security cards. They also discovered receipts logging more than $14,400 in credit card purchases from several area home improvement stores. Apparently, the thief was reselling the home improvement supplies below retail prices and trading them for drugs.

The Sheriff's prime suspect for the ID thefts was a 30-year-old woman named Paige Kay Wolfenberger. She was arrested on nine felony counts of identity theft, possession of a forged driver's license and being a convicted felon in possession of a firearm. (She was on probation from a 1999 drug conviction.) They

arrested several other people on charges related to the drug labs.

Several months later, in September, Wolfenberger pleaded no contest to two felony counts of identity theft. She accepted a **16-month prison term** as part of a deal that dismissed the seven other felony counts.

ID theft has long been associated with illegal drug use. But, starting in the early 2000s, police and prosecutors around the U.S. started noticing a refinement in the criminal use of ID theft. Criminals would steal someone's identity for the sole purpose of giving police false information upon arrest—and minimizing or avoiding subsequent prosecution.

The trend was illustrated in a case that involved more than a dozen police officers scouring a downtown Las Vegas neighborhood in October 2002, in search of a woman using the name Tiffany May.

The woman, a **prostitute** who'd been working Las Vegas's seedier neighborhoods for years, was suspected of taking a baby girl without the permission of the baby's mother. The facts turned out to be complicated. The baby's mother had left the baby with her grandmother. The grandmother—an acquaintance of the woman claiming to be Tiffany May—had left the baby with "Tiffany May." Later, the baby's mother became upset when she couldn't find either her baby or the woman claiming to be Tiffany May.

Las Vegas police circulated a missing child flier with a mug shot and physical description of the prostitute; above the mug shot was the name *Tiffany May*. The police recovered the child fairly quickly—the woman

claiming to be Tiffany May had **left the baby girl** in the care of an elderly couple who had no idea who the child's mother really was.

The woman claiming to be Tiffany May wasn't; and the police suspected as much. The real Tiffany May turned out to be a much different person—a law abiding citizen who lived in a quiet Las Vegas neighborhood with her mother. She wasn't pleased to learn that a hooker and possible kidnapper had been using her name.

The real Tiffany May had lost her Social Security card and a Clark County Health District photo ID card about 18 months earlier.

Las Vegas police were familiar with the fake Tiffany May from years of regular prostitution arrests; they just weren't sure about her real name (though they had several aliases). She'd been using the name *Tiffany May* for more than a year.

In a less convoluted case, police and court officers in Sandoval County, New Mexico, thought they had their man when they arrested and convicted him for a DWI…twice. And they thought their man was named Bryce Roland.

In October 1996, a Sandoval County sheriff's deputy stopped and charged a man with drunken driving and not having a driver's license. The man told the deputy his name was Bryce Roland and offered a birth date and SSN that checked out. The man posted

bond, made all his court appearances and pleaded guilty to the charges. He was sentenced to and served two days in jail.

In November 1999, the District Attorney's Office received a call from Bryce Roland near Milwaukee asking that the DWI conviction be set aside—because he was not the man pulled over in Sandoval County.

The DWI conviction was taken off Roland's record.

Then, in February 2000, local police stopped a man on suspicion of DWI who gave his name as Bryce Roland and had the correct birth date and Social Security number. The man pleaded guilty to a first offense DWI in municipal court, made his appearances, spent one night in jail, paid his fines and completed the MADD Victim's Impact Panel.

Less than a year later, the real Bryce Roland called the District Attorney's Office again and told the staff lawyers that his license was being revoked for a **DWI he did not commit**. He asked that the second DWI conviction also be stricken from his record. Then, he called the Wisconsin Social Security Administration about any further fraud.

Roland told Wisconsin investigators that he had only been to New Mexico once, passing through on his way to California. But his Social Security card and birth certificate had been stolen in Milwaukee in 1994. And the real Bryce Roland knew that someone had obtained credit in New Mexico using his Social Security number.

Social Security investigators discovered that, in 1998, someone in New Mexico had been issued a duplicate Social Security card using Roland's number.

Within a few months of the second phone call from the real Bryce Roland, Arizona officials announced the indictment of Edward J. Wolsiffer, indicted on 17 counts of forgery and one count each of fraud, theft of identity and **concealing identity**. He was also indicted on two DWI charges that he was previously convicted of under the stolen name.

When Wisconsin investigators ran Roland's name through the Social Security and criminal databases, Wolsiffer's name also came up.

Sandoval County records showed that a Wolsiffer had been arrested on a traffic stop in 1998 and was due to be extradited to Indiana as a habitual traffic offender. Wolsiffer did not give police Roland's ID information that time, as he had in 1996 and would again in 2000.

CONCLUSION

Identity theft is often an enabling crime—one that occurs in conjunction with other crimes. When it comes to these *other crimes*, illegal immigration, terrorism and drug use (or distribution) are the most common. From a law enforcement and public policy perspective, these other crimes can result in some good. They can draw more attention—and more financial resources—to the fight against ID theft.

CHAPTER 6

LAWS AND AGENCIES THAT PROTECT YOU...OR DON'T

In October 1998, Congress passed the Identity Theft and Assumption Deterrence Act of 1998 (**Identity Theft Act**) to address the problem of identity theft. Specifically, the Act amended federal law to make it a federal crime when anyone:

> ...knowingly transfers or uses, without lawful authority, a means of identification of another person with the intent to commit, or to aid or abet, any unlawful activity that constitutes a violation of federal law, or that constitutes a felony under any applicable state or local law.

The Identity Theft Act **accomplished four things**:

1) It identified people whose credit had been compromised as true victims. Historically, with financial crimes such as bank fraud or credit card fraud, the victim identified by statute was the person, business or financial institution that lost the money. Often, the victims of identity theft—whose credit was destroyed—were not recognized as victims.

2) It established the Federal Trade Commission (**FTC**) as the **one central point of contact** for people to report all instances of identity theft. This collection of data on all ID theft cases allows for the identification of systemic weaknesses and the ability of law enforcement to retrieve investigative data from one central location.

3) It provided **increased sentencing potential** and enhanced asset forfeiture provisions. These enhancements help to reach prosecutorial thresholds and allow for the return of funds to victims.

4) It closed some loopholes in federal law by making it **illegal to steal another person's personal identification information** with the intent to commit a violation. Previously, only the production or possession of false identity documents was prohibited.

In April 1999, representatives from 10 federal law enforcement agencies, five banking regulatory agencies, the U.S. Sentencing Commission, the National Association of Attorneys General and the New York State Attorney General's Office met with the FTC to share their thoughts on what the FTC's complaint database and a related consumer education booklet should contain.

In November 1999, the **FTC opened the consumer hotline** and began adding complaints to the resulting **ID Theft Clearinghouse**. Law enforcement organizations nationwide who were members of the Con-

sumer Sentinel Network (the FTC's universal fraud complaint database) gained access to the Clearinghouse via a secure Web site in July of 2000.

The Clearinghouse provides a comprehensive picture of the **nature, prevalence and trends** of identity theft. In 2000, the first full year of operation, the FTC entered more than 31,000 consumer complaints into the database; in 2001, that number grew to more than 86,000. In 2002, it was nearly 200,000.

Since the **inception of the Clearinghouse**, 46 separate federal agencies and 300 and six different state and local agencies have signed up for access to the database. Among the agencies represented are over half the state Attorneys General as well as law enforcement from a number of major cities—including Baltimore, Dallas, Los Angeles, Miami, San Francisco and Philadelphia.

According to Howard Beales, Director of the FTC's Bureau of Consumer Protection:

> The Clearinghouse is essentially a **tool for criminal investigators and prosecutors**. The U.S. Postal Inspection Services, the United States Secret Service, the SSA, the Department of Justice and the IACP [International Association of Chiefs of Police], along with many other agencies, are outstanding partners in this effort, consistently communicating the availability and advantages of the Clearinghouse to their colleagues…

> Recognizing that investigating identity theft often presents unique challenges, the FTC in

conjunction with the Secret Service, DOJ and IACP planned and directed training seminars for state and local law enforcement around the country.

One critical point, though: The FTC doesn't have investigative or other direct law enforcement powers. Violations of the Identity Theft Act are **investigated by federal agencies** such as the U.S. Secret Service, the FBI and the U.S. Postal Inspection Service, and prosecuted by the Department of Justice and local law enforcement agencies like police, sheriffs and state troopers.

In his May 2001 congressional testimony, Bruce Townsend—the Special Agent in charge of the Secret Service's Financial Crimes Division—described the ways that it works with various law enforcement agencies on ID theft cases:

> Our investigative program focuses on three areas of criminal schemes within our core expertise. First, the Secret Service emphasizes the investigation of counterfeit instruments. By counterfeit instruments, I am referring to counterfeit currency, counterfeit checks—both commercial and government—counterfeit credit cards, counterfeit stocks or bonds, and virtually **any negotiable instrument** that can be counterfeited. Many counterfeiting schemes would not be possible without the compromise of the financial identities of innocent victims.

> Second, the Secret Service **targets organized criminal groups** that are engaged in financial crimes. Again we see many of these

groups, most notably the Nigerian and Asian organized criminal groups, prolific in their use of stolen financial and personal information to further their financial crime activity.

Finally, we focus our resources on **community impact cases**. The Secret Service works in concert with the state, county and local police departments to ensure our resources are being targeted to those criminal areas that are of a high concern to the local citizenry. Further, we work very closely with both federal and local prosecutors to ensure that our investigations are relevant, topical and prosecutable under existing guidelines.

JURISDICTIONAL CHALLENGES

Cooperation among law enforcement agencies can be a tricky issue; often, turf battles erupt over which agency should lead an investigation in a given place.

> Cooperation is especially important in ID theft cases because ID thieves routinely operate in a multi-jurisdictional environment. In other words, they may steal personal information in one state and then use it in another. Or they may use the Internet to buy items—further blurring the location of the crime.

This has created problems for local law enforcement who generally respond first to criminal activities. By

working closely with other federal, state and local law enforcement, as well as international police agencies, the Feds—especially the Secret Service, FTC and FBI—have been able to provide a comprehensive **network of intelligence sharing**, resource sharing and technical expertise that bridges jurisdictional boundaries.

> Anecdotes tell the story. For example, a grand jury in Florida reported that some of the state's law enforcement agencies were reluctant to take identity theft complaints and don't generate reports in some cases.

Funding, too, is a roadblock to enforcement. A deputy district attorney in Los Angeles County, Calif., told the U.S. General Accounting Office (GAO) that there were **not enough prosecutors** to handle the county's identity theft cases.

The GAO heard similar complaints from a supervisor in the Consumer Fraud Division of the Cook County (Ill.) State's Attorney's Office, the second largest prosecutor's office in the nation. The supervisor said more money was needed to **train local police agencies** on how to handle cases involving multiple victims and voluminous documents.

A chief deputy attorney in Philadelphia said that "given competing priorities and other factors, there is little incentive" for police departments in Pennsylvania to spend money on identity theft probes.

WHAT LAW OFFICERS SAY

In his May 2001 congressional testimony, Joseph Cassilly—the State Attorney for Harford County, Maryland—described the jurisdiction problem:

> One of the major problems of state law enforcement has nothing to do with technology but is basic **jurisdiction and cost efficiency**. The majority of frauds and thefts are under $100,000 and usually involve parties resident in different states. The federal authorities have little interest in cases under $1 million—so most of the caseload will naturally fall to the states. But will a prosecutor be willing or have the resources to extradite on a $5,000 theft case?

So, the local police department is the **first responder** to the victims once they become aware that their personal information is being used unlawfully. Then, when evidence points to a multiple-state crime…or the involvement of the U.S. Postal Service…the local cops will hand the case to the Feds.

On the other hand, credit card issuers and other financial institutions usually contact local Secret Service field offices to report possible criminal activities.

The **partnership approach** to law enforcement is exemplified by financial crimes task forces located throughout the country. These task forces pool personnel and technical resources to maximize the expertise of each participating law enforcement agency.

> The Feds also work with private-sector groups (especially in the banking and financial services industries) on preventive and investigative programs.

In the early 2000s, the main cooperative law enforcement entity was the **Identity Theft Subcommittee** of the Attorney General's White Collar Crime Council. This group, which is made up of federal and state law enforcement, regulatory and professional agencies, meets regularly to discuss and coordinate investigative and prosecutorial strategies as well as consumer education programs.

In his July 2002 congressional testimony, Dennis M. Lormel—Chief of the FBI's Terrorist Financial Review Group—described the FBI's approach to investigating and prosecuting ID theft:

> [T]he FBI, along with other federal law enforcement agencies, investigates and prosecutes individuals who use the identities of others to carry out violations of federal criminal law. These violations include bank fraud, credit card fraud, wire fraud, mail fraud, money laundering, bankruptcy fraud, computer crimes and fugitive cases. These crimes carried out using a stolen identity make the investigation of the offenses much more complicated. The use of a stolen identity enhances the chances of success in the commission of almost all financial crimes. The stolen identity provides a cloak of anonymity for the subject while the groundwork is laid to carry out the crime. This includes the rental of mail

drops, post office boxes, apartments, office space, vehicles and storage lockers as well as the activation of pagers, cellular telephones and various utility services.

Lormel also made a point that many law enforcement types admit more quietly—but many victims of ID theft see as a problem:

> The Federal Bureau of Investigation does not view identity theft as a separate and distinct crime problem. Rather, it sees identity theft as a **component of many types of crimes** that we investigate.

The FBI would rather battle things like terrorism and drug import—and deal with ID theft as a by-product of those. However, it's helpful to remember that the Secret Service considers ID theft a higher priority in its own right.

Richard J. Varn—Chief Information Officer for the State of Iowa—offered some remedies to common jurisdictional problems in his April 2002 congressional testimony:

> There is a crying need for coordination at each level of government and between levels of government on identity security on technical standards and systems and in policy making. It is not yet clear what the best options or mix of options are for this coordination. Some possible choices include:

- Interstate **compacts**;

- Intergovernmental agreements;

- Standards development through recognized standards bodies;

- Coordination of information technology system architecture, development and operation;

- Federal funding for **enhanced life document systems** and driver's license issuing processes, systems and cards;

- Legislative and executive **coordination** of the funding, development, enhancement and implementation of identity security programs and systems within and among each level of government;

- Establishment of a **single point of contact** and coordination for various federal initiatives; and

- Creation of formal or informal federal, state and local groups to coordinate technical and policy activities and exchange information.

THE MAY 2002 ID THEFT SWEEP

In May 2002, U.S. Attorney General John Ashcroft announced the completion of a national "sweep" of

ID theft prosecutions. The sweep involved 73 criminal prosecutions against 135 individuals in 24 districts over a couple of days.

Justice Department officials noted that the sweep was the first part of a **two-pronged strategy** by federal law enforcement to combat identity theft. The second prong involved efforts to strengthen existing federal identity theft criminal statutes.

> **The sweep was a good example of cooperation between the Feds and law enforcement agencies at the state and local levels.**

One case under investigation by the FBI in conjunction with the U.S. Postal Inspection Service involved a man who'd obtained personal information—names and birth dates—of attorneys in the Boston area from the **Martindale-Hubbell directory** of attorneys. Using this information, he and a co-conspirator visited the Massachusetts Bureau of Vital Records—which had an open records policy—and were able to obtain copies of birth certificates of their victims. Using that information, they were able to contact the Social Security Administration and obtain SSNs for most of the attorneys. Once they had the SSNs, the thieves **ordered credit reports** and looked and determined the attorneys' creditworthiness and existing accounts. Their first theft was to call one of the attorney's banks and order a wire transfer of $96,000. Half of the money went to a casino and the rest went into the crook's personal accounts.

This was a stupid first move. Once the bilked attorney realized the money was missing, he notified his bank—and the bank notified the Office of the Comptroller of the Currency and the FBI. The FBI got the necessary warrants and the wire transfers were easy for the bank to trace.

In the meantime, the crooks were still using the stolen IDs. They added themselves as authorized users to the credit card accounts of several attorneys and ordered emergency replacement cards from others. By the time the FBI and Massachusetts police arrested the two, they had at least 12 different license or identification cards from three states and at least four or five credit cards, all in the names of the attorneys whose identities they'd stolen.

> With stories like this one circulating in post-9/11 America, politicians in Washington D.C. realized that the 1998 Identity Theft Act wasn't a strong enough protection.

California Senator Dianne Feinstein led the drafting of the **Identity Theft Penalty Enhancement Act** of 2002, which allowed harsher charging and sentencing when identity theft occurs in connection with these other serious crimes.

The sentencing enhancements would increase penalties for the most serious forms of identity theft and strengthen prosecutors' ability to bring these cases. In particular, the proposed legislation would define a new crime of **"aggravated identity theft"** that in-

cludes the most damaging forms of identity theft, and which would carry greater penalties. Enhanced five-year consecutive penalties would result if a terrorist or terrorist-related offense is involved.

The proposed law also **streamlined proof requirements** by including the possession of identifying information with intent to commit identity theft as an element of the crime. These provisions, together with the enhanced sentences for aggravated identity theft, made ID theft cases easier to investigate and to prosecute successfully.

THE PATRIOT ACT

Feinstein's Enhancement Act wasn't the only new law designed to help federal prosecutors clamp down on ID thieves. An even more potent—though more controversial—tool was the **USA Patriot Act** of 2001. This law, enacted in the weeks after the 9/11 attacks, made significant changes to how the Feds could investigate and prosecute a variety of suspects—including suspected ID thieves.

> Most of the controversies surrounding the Patriot Act had to do with its effects on constitutional privacy rights. The parts of the Act designed to combat ID theft were more technical...and less controversial.

New rules related to opening bank accounts were announced during the summer of 2002 and were designed to thwart terrorist funding—but could also

help fight identity theft and other forms of fraud. The rules required financial institutions (including banks and trust companies, savings associations, credit unions, securities brokers and dealers, mutual funds and futures merchants or brokers) to implement "reasonable procedures" for:

1) **verifying the identity** of any person seeking to open an account, to the extent reasonable and practicable;

2) maintaining records of the information used to verify the person's identity; and

3) determining whether the person appears on any list of known or **suspected terrorists** or terrorist organizations.

The U.S. Treasury Department and the Social Security Administration agreed to develop and implement a system by which banks and other financial institutions could access a database to verify the authenticity of SSNs provided by people opening accounts.

The financial institutions subject to the proposed rules would also be required to establish programs specifying procedures for obtaining identifying information from customers seeking to open new accounts.

A joint agency statement issued by the Treasury Department and the SSA said:

> This identifying information would be essentially the same information currently obtained by most financial institutions and for individual customers generally, including the customer's name, address, date of birth and an identification number (for U.S. persons, a

Social Security number and for non-U.S. persons, a similar number from a government-issued document). Customers with signature authority over business accounts would furnish substantially similar information.

The proposed rules raised concerns mostly from credit card issuers. They complained the new rules would create problems especially for **online applications**.

CALI'S ANTI-ID THEFT LAW

About the same time that the Feds were announcing new banking rules derived from the USA Patriot Act, California was putting a new law into effect that prohibited the public posting or display of an individual's SSN—including printing the number on any card required to access products or services.

This state law got a lot of media attention as both a privacy protection and a blow to easy ID theft.

The California law also stated that no one could be required to transmit his or her Social Security number over the Internet, unless the connection were secure or the SSN encrypted. And institutions were **not allowed to print** an individual's SSN on any mailed materials, unless required by state or federal law.

The law did not prohibit the collection, use or circulation of SSNs for internal verification or administrative purposes. But, if a California resident sent a written request to a bank or other institution requesting that his or her SSN not be used, the request had to be honored within 30 days of receipt—without any additional fee. And financial institutions could not deny services to any individual who opted out.

> Although the law only applied to California, people in the banking industry admitted it would have a national effect. An executive with an Ohio-based financial services company that had branches in most of the U.S. said it would be much easier to apply the California rule nationally than to segment customer data by state.

While some banks had already stopped using SSNs by 2002, others used encryption techniques to obscure the numbers. These encryption techniques fall into two basic categories: Some use **algorithms to alter SSNs**; others hide the first five digits of SSNs on all documents.

No sooner did the California rule go into effect than politicians there considered expanding it. One new proposal would allow customers to tell financial institutions not to share or sell their personal financial information—either to corporate affiliates or to third parties. This option, as we've already seen in previous chapters, is known as the *opt-out*.

In limited circumstances, where the third party was not a financial institution, customers would have to give **explicit permission for data-sharing** ahead of time.

Other states were also sharpening their laws against ID theft:

- In Georgia, businesses could be fined up to $10,000 for the improper disposal of materials that contain personal informa-

tion about customers. The new law also applies to information that is spoken, visual or electronic.

- In October 2002, a New York law made stealing a person's identity and possessing personal information a felony for the first time. The law allowed prison sentences of up to seven years for those convicted of using ID theft to steal more than $500. One interesting point: the law included references to security technologies not yet in general use—such as voice prints or retina scans.

- In November 2002, Virginia Attorney General Jerry Kilgore said he would recommend that the state's General Assembly strengthen penalties against ID theft. Kilgore also urged local police to pursue the crime more aggressively.

So, the strengthening of ID theft laws at the state level makes for a kind of balance…since local law enforcement is on the front lines of the problem.

LAWS THAT HELP ID THIEVES

Hovering in the background of the federal and local efforts to strengthen the laws against ID theft is an issue that seems ridiculous—some laws actually **enable ID theft**.

In the fall of 2002, ID theft became a hot-button issue in King George County, Virginia. About two dozen King George residents complained to county officials after learning their SSNs were online in computerized versions of some court records, including

mortgage-related documents. The personal information appeared on land records uploaded to the county Web site as part of the jurisdiction's efforts to bring all of its files up to date electronically.

> The local bosses cited a 1998 Virginia law that mandated that clerks charge a $3 technology fee for the purposes of updating their databases when records were filed—although, whether the information was put online remained up to the clerk of the court.

The King George County executive pointed out that, if a resident filed a complaint, his or her sensitive data would be removed from the site. And documents that were scanned and uploaded online would, in the future, exclude any sensitive information.

The executive pointed out that **marriage license records** also contained personal information, including dates of birth and maiden names of mothers. This information was a matter of public record and could be viewed by anyone who visited the county courthouse.

Other Virginia counties took steps to protect identities. A clerk in one nearby county pointed out that her office only made information online available to companies or agencies that had **established their bona fides**—and paid for the service.

In another nearby county, the records manager said that his office also controlled access by offering a **subscription service** to professional firms. He noted

that the subscription model actually made the system more secure, because he could monitor who was looking at which documents.

During the summer of 2002, Florida real estate appraisers protested a state law would make some 500,000 SSNs public—putting the owners at risk for identity theft. The appraisers claimed that, starting that fall, they would have to release the Social Security numbers of Floridians who had homesteaded property to any business that requested them.

> Specifically, the law held that state and county agencies must give SSNs to "reasonable businesses" with a "legitimate business purpose" for the numbers, such as research or verifying information.

The law required the businesses to submit a **written request** and to explain why they wanted the numbers; those requests would be kept on file with state officials.

In 2000, Florida property appraisers had started collecting SSNs for **homestead exemption**—a state program that allows real estate owners to keep their property, regardless of court judgments, tax liens or other encumbrances. The numbers were used for identification to prevent tax fraud, and they had been kept confidential under state law.

The new law was explained at various times as a security measure and as a consumer advocacy measure; in fact, its origins traced back to **lobbyists for direct**

marketing companies. But various politicians in Florida's capital—as well as the leader of the state's property appraisers association—insisted that the law did not apply to property appraisers' use of SSNs on homestead exemption forms.

In late 2002, a series of surveys of residents in Washington state reflected growing concern about that state's laws granting broad **public access to government records**. The laws—which had traditionally been defended as signs of clean government and no corruption—also posed a threat to ID security.

> The main survey showed that the more concerned someone is about identity theft and invasion of privacy, the less that person will support access to government records by the media. The results were mixed: Nine out of 10 adult Washington residents said they favored open government; but three-quarters were concerned about misuse of information by the press and identity thieves.

The survey was conducted to mark the 30th anniversary of Washington's aggressive **Public Disclosure Act**; it was sponsored in part by the Washington Coalition for Open Government, an organization dedicated to defending the people's right to access.

Finally, and most disturbingly, some states cut straight to the point and **sell personal information** to private companies.

> California, despite its privacy laws, has sold its state birth index—containing personal information on about 24.6 million people—to an online Web company.

Pennsylvania's Corporation Bureau sells loan-related public records that include SSNs of citizens. Specifically, the state's Corporation Bureau sells and makes available to the public Uniform Commercial Code financing statements that contain sensitive personal information.

The so-called "UCC" filings often list debtors' SSNs, addresses and even driver's license data. The Bureau generated about $100,000 a year through the late 1990s and early 2000s by selling the records to companies—most often direct marketers in the **commercial loan business**.

In 2002, when the sale caused some controversy, state officials said they were powerless to change their procedures. They cited a state law that required the Bureau to accept filing of a nationally-recognized UCC form that included a blank for SSNs. The law precluded the Bureau from altering the form, which was a public record.

CONCLUSION

If ID theft could be stamped out by passing a strong law, things would be much easier. But ID theft—and ID thieves—is complex. In many cases, the crooks exploit turf battles between government bureaucra-

cies. In a few cases, they take advantage of badly-drawn laws that actually help with ID theft.

The ID Theft Clearinghouse managed by the Federal Trade Commission is a tool designed to coordinate law enforcement efforts in the U.S. And the Secret Service is the federal agency that makes the strongest priority of battling ID theft.

But, in the end, local law enforcement—police and district (or state's) attorney—end up dealing with most ID theft cases. If you've been a victim of ID theft, it's those local agencies that will most likely help.

7

BANKS AND
CREDIT BUREAUS

In 1999, Congress passed the Gramm-Leach-Bliley Act (the GLB Act), legislation that allowed banks, insurance companies, credit bureaus and securities firms to affiliate under a **single corporate structure**. The purpose of this change? To allow financial services companies to "more readily anticipate and meet their customers' financial needs."

At least that's what the head of the Financial Services Roundtable told Congress in March 2001.

The GLB Act also **reformed the system of federal regulation** and requires greater coordination among the various agencies. This coordination is a challenge. In all, there are almost 200 different financial services regulators—including the various state banking, insurance and securities regulators and all of the federal banking, thrift and securities agencies.

As **integrated financial services** companies have increased the scope of their business activities—mixing banking, investments, insurance and consumer lending—they have become more directly involved in establishment and use of personal financial identities. In

fact, they've **marketed these identities**. As recently as the 1990s, most Americans were only vaguely aware of their credit ratings or "FICO scores." In the early 2000s, financial institutions have marketed these credit profiles **like soap or soft drinks**. One example: In 2002 and 2003, radio and television ads for new cars started referencing "credit tiers" when describing available financing packages.

> As a result, financial identities—credit scores—have become commodities, with market values. And, as any economist will tell you, commodities are significant in two ways. First, their value is defined by marketplace conditions that are usually beyond any single owner's control; second, they are vulnerable to theft, piracy and manipulation.

These are the **economic trends** that have enabled identity theft.

What do the fast-integrating financial services companies think about ID theft? In his March 2001 congressional testimony, Steve Bartlett—President of the Financial Services Roundtable—put the problem in context:

> It is estimated that the financial services industry loses more than $100 billion a year in fraud, which includes $85 billion to $120 billion in insurance fraud, $24 billion of which comes from property/casualty fraud; $13 billion in check fraud; $3 billion in identity fraud; and $600 million in credit card fraud.

So, the financial services companies think that insurance fraud is their biggest problem. But ID theft is, by most accounts, the fastest growing **form of financial fraud**; and, as we've seen throughout this book, ID theft often operates in conjunction with other kinds of fraud—including insurance fraud.

CREDIT BUREAUS

When most Americans hear the term "financial services," they think of faceless corporate giants that buy lots of ads during the Super Bowl. Beyond that, they have a vague notion of companies that combine banking, insurance, stock brokerage and various other money-related activities.

> One of the key "various other" activities is the setting and tracking of individual consumer's credit ratings.

Throughout this book (and any discussion of ID theft) you've heard references to the "big three" U.S. credit bureaus—Equifax, Experian and TransUnion. These companies—along with a fourth, slightly different credit rating company called Fair, Isaac & Co.—control the U.S. **consumer credit rating industry**. Their importance to the financial services industry is large…and growing. And their role in the growth of ID theft is worth some consideration.

Like most credit bureaus, the big three keep files that include personal information like SSNs and account information of individual consumers. But their cli-

ents are not the people whose information they keep; their clients are the **banks and consumer finance companies** who decide whether…and on what terms…to lend money to those individuals.

Many people make the mistake of assuming that credit bureaus exist to serve individual consumers—and get frustrated with the lack of responsiveness and customer service that the credit bureaus have traditionally offered. (If you have a problem with a credit report, it's virtually impossible to contact anyone at Equifax, Experian or TransUnion directly. The best you can usually manage is to leave a telephone message or fax a letter to a generic recipient.)

> **If you remember that you're not the credit bureau's primary customer, you may understand the cool reception the credit bureaus give you.**

The problem with this approach to the handling of credit information is that it accepts a **higher level of inefficiency** than most consumers would like. In this way, the credit industry is something like the health insurance industry—in both cases, the primary customers (lenders, in the case of credit bureaus; employers, in the case of health insurance) are not the end-users of the services being sold. So, it's logical that the services treat the end-users roughly.

An economist looking at these industries would likely conclude that the unusual structure of primary customer/end user is not intended for efficiency—if efficiency means the timely and accurate delivery of ser-

vices to the greatest number of users. No, the unusual structure is likely intended for some other purpose. **Cost control** would be a good guess.

> In health insurance, the cost controls provided by the traditional (at least in the U.S.) employer-provided model are gradually eroding. Despite the bad impression that some people have of it, the managed care model of health coverage is moving more control of that marketplace to end-users.

Is there any equivalent movement in the credit rating industry?

The Fair Credit Reporting Act (FCRA) is an attempt by the U.S. government to **restore some balance and accountability** to the credit rating industry. According to the Federal Trade Commission:

> The FCRA is designed to promote accuracy, fairness and privacy of information in the files of every "consumer reporting agency" (CRA). Most CRAs are credit bureaus that gather and sell information about you—such as if you pay your bills on time or have filed bankruptcy—to creditors, employers, landlords and other businesses.
>
> You must be told if information in your file has been used against you. Anyone who uses information from a CRA to take action against you—such as denying an application for credit, insurance or employment—must tell you, and give you the name, address and

phone number of the CRA that provided the consumer report.

You can find out what is in your file. At your request, a CRA must give you the information in your file, and a list of everyone who has requested it recently. There is no charge for the report if a person has taken action against you because of information supplied by the CRA, if you request the report within 60 days of receiving notice of the action. You also are entitled to **one free report** every 12 months upon request if you certify that:

1) you are unemployed and plan to seek employment within 60 days;

2) you are on welfare; or

3) your report is inaccurate due to ID theft or other fraud.

Otherwise, a CRA may charge you for a copy of your credit report.

You can **dispute inaccurate information** with the CRA. If you tell a CRA that your file contains inaccurate information, the CRA must investigate the items—usually within 30 days—by presenting to its information source all relevant evidence you submit (unless your dispute is deemed frivolous by the CRA). After that, the FCRA sets the rules for how corrections are made:

- The source must review your evidence and report its findings to the CRA. The source also must advise other CRAs to which it has provided the data of any error. The CRA must give you a **written**

report of the investigation and a copy of your report if the investigation results in any change.

- Inaccurate information must be **corrected or deleted**. A CRA must remove or correct inaccurate or unverified information from its files, usually within 30 days after you dispute it. However, the CRA is not required to remove accurate data from your file unless it is outdated or cannot be verified.

- If the CRA's investigation does not resolve the dispute, you may add a **brief statement** to your file. The CRA must normally include a summary of your statement in future reports. If an item is deleted or a dispute statement is filed, you may ask that anyone who has recently received your report be notified of the change.

- You can dispute inaccurate items with the **source of the information**. If you tell anyone—such as a creditor who reports to a CRA—that you dispute an item, they may not then report the information to a CRA without including a notice of your dispute.

Outdated information may not be reported. In most cases, a CRA may not report negative information that is more than **seven years old**; 10 years for bankruptcies.

Access to your file is limited. A CRA may provide information about you only to people with a need

recognized by the FCRA—usually to consider an application with a creditor, insurer, employer, landlord or other business.

Your **consent is required** for reports that are provided to employers or reports that contain medical information. A CRA may not give out information about you to your employer, or prospective employer, without your written consent. A CRA may not report medical information about you to creditors, insurers or employers without your permission.

> You may choose to exclude your name from CRA lists for unsolicited credit and insurance offers. Creditors and insurers may use file information as the basis for sending you unsolicited offers of credit or insurance.

Such offers must include a toll-free phone number for you to call if you want your name and address removed from future lists. If you call, you must be **kept off the lists for two years**. If you request, complete and return the CRA form provided for this purpose, you must be taken off the lists indefinitely.

> You may seek damages from violators. If a CRA, a user or (in some cases) a provider of CRA data violates the FCRA, you may sue them in state or federal court.

CREDIT BUREAUS RESPOND

The FCRA has been on the books for more than decade—and it's been updated and modified on a regular basis to reflect changes in the credit and financial services industries. But no amount of regulation—however well intended—has the same effect as a **change in market conditions**.

> For years, the industry refused to sell scores to consumers, saying officially that they would be misconstrued. (But, in fact, they didn't want to shift their focus away from their paying customers—banks and lenders.)

The consolidation among banks and other financial institutions that followed the GLB Act in the early 2000s has brought attention to the critical role that credit bureaus (CRAs, in the jargon of the law) play in financial services. As a result, the CRAs have started to adjust their businesses to **serve end-users** more directly.

Starting in late 2002, the companies that sell credit information to lenders began various **campaigns to convince consumers** to buy their services.

In early 2003, Experian (which began its corporate life as part of the conglomerate TRW—and the reason that some people refer to their credit rating as their "TRW") began providing consumers with their scores on a monthly basis, so they could monitor changes. Experian also launched an "optimizer" ser-

vice that would tell consumers the specific ways they could boost their individual credit ratings.

In the fall of 2002, Equifax, Inc.—the oldest and, generally considered, the largest credit bureau—and ChoicePoint Inc., an affiliated writer of scoring formulas, began selling consumers' insurance scores. Equifax also sold credit reports and credit scores to individuals.

TransUnion—by most accounts, the smallest of the big three credit bureaus—followed the other two bureaus and announced that it would sell individual credit reports combined with credit scores produced by Fair, Isaac & Co. for $12.95—or in a $38.85 package that let consumers review their data four times in a year.

Frankly, the CRAs hope to **tap into anxieties of people** who worry about ID theft. Of course, they explain their efforts differently. In the press releases and for public consumption, the CRAs talk a lot about how "consumer education" is the best tool for combating ID theft.

But some consumer advocates are skeptical. John and Mary Elizabeth Stevens are two such vocal consumer advocates. They've written:

> Identity theft is only possible with the full co-operation of three major participants: the impostor, the creditor and the credit bureau. All are co-conspirators and equally guilty of identity theft. …The perpetuation of identity theft has created a new product line for the

credit bureaus, which now sell services alerting cardholders to significant changes on their credit reports.

Not surprisingly, the credit bureaus take great offense to the notion that they are complicit in the boom in ID theft during the late 1990s and early 2000s. But their complicity may not have been direct…or intentional.

The fact is that the credit bureaus have the computer files of personal financial information that every ID thief seeks. And all of the major ID theft cases that have come to light in the U.S. during the 1990s and 2000s have involved—to some degree and, in some cases, indirectly—**information taken from credit bureau files**.

Again, assuming the perspective of a disinterested economist, the inefficiencies created by the CRAs' primary customer/end user split and their general restriction of access to information contributed to a marketplace that didn't respond quickly to manipulation and abuse. When a market—especially a market in information—is managed to be inefficient, it's **ripe for thieving**.

FAIR, ISAAC & CO.

While the big three credit bureaus take most of the scrutiny from consumer advocates and laws like the FCRA, one company has had a **huge influence over the credit industry** but a lower regulatory and public profile—until the early 2000s.

California-based Fair, Isaac & Co.—which goes by the abbreviation FICO—writes algorithms and other mathematical formulas that convert the data in credit reports into widely-used credit *scores*. The company's formulas are used nearly everywhere in the U.S.; so, FICO has had an influence over the American financial services industry that's much larger than its relatively small corporate size. ("FICO score" has largely replaced the previously-mentioned "TRW" as shorthand for *personal credit rating*.)

> FICO has traditionally been careful to point out that it is not a credit bureau. It doesn't keep files on individual consumers. Therefore, it is unlikely to be complicit in any specific ID theft.

But FICO has participated in the trend toward marketing its credit services to consumers. In November 2002, it launched a $69.95 **credit-monitoring service** called Score Power. And it began selling its scores in a $39.95 package that included credit reports from the big three credit bureaus as part of the "consumer credit empowerment services" available at its Web site.

Subscribers would receive four Score Power reports for monitoring changes to their FICO score and their Equifax credit report. Score Power also provides Fair, Isaac's score analysis that "provides insight into the same information lenders use, in order to help consumers improve their true credit potential over time."

Why would a consumer pay for a credit-monitoring service from a company that doesn't keep consumer information itself? Because FICO markets itself as the **brains behind the credit decisions** that lenders and finance companies make. And, in a highly publicized deal that took place in 2002, it acquired HNC Software—which specialized in thwarting credit card fraud.

> Ultimately, FICO—like the CRAs—may not care whether consumers use their services. The consumer services may be little more than a public relations effort to thwart further regulatory and political hassles.

Like the credit bureaus, FICO's real customers are **lenders and corporations** that pay for computer programs that help them sort through the customer data stored at the big three credit bureaus. About three-quarters of the company's revenues come from **royalties on computer programs**. For example: It offers credit card companies better ways to highlight riskier accounts before they become delinquent. Repeated cash advances and large-balance transfers are red flags suggesting overextended credit.

The thread that holds most of FICO's programs together is the SSN. In most cases, it's the mechanism for searching across several databases. And this use of SSNs creates exactly the sort of information bottle-neck that makes ID theft so devastating.

CRAs CIRCLE THEIR WAGONS

Beginning in late 2001, a group of bills were proposed in Washington D.C. and various state capitols that would limit the ability of credit bureaus and government agencies to sell their information to private-sector marketing firms. The main mechanism for enforcing these limits would be a restriction on sharing SSNs. These bills were generally promoted as protections of privacy and against ID theft.

The credit bureaus didn't agree. And they sent lobbyists to fight the privacy bills wherever they could.

Associated Credit Bureaus (ACB) is an international trade association representing 500 consumer information companies that provide "fraud prevention and risk management products, credit and mortgage reports, tenant and employment screening services, check fraud and verification services and collection services." In November 2001 congressional testimony, the ACB's Stuart K. Pratt said:

> The key to ensuring that both the government and the private sector can fully authenticate identifying information on applications of all types is through a **robust system of authentication and verification technologies**. At the core of these technologies is the availability of validated consumer identification information for cross-matching purposes.

> Our members' systems are a good example of how the private sector is already integrating a range of information sources today.

Key in this integration is the freedom to develop fraud prevention products for a range of industries.

Unfortunately, for example, the current FTC rules…seriously impinge on the use of essential consumer identifying information for non-Fair Credit Reporting Act purposes.

In fact, the rule may foreclose on any opportunity to use credit header for other types of security screening efforts, such as scanning airline passenger manifests.

The "essential consumer identifying information" included SSNs. Sharing these had a lot more to do with marketing consumer data to direct mail companies than preventing terrorist from boarding airplanes.

And sharing SSNs with direct mail companies creates a real exposure to ID theft.

The **Individual Reference Services Group** (IRSG) is a group of the leading information industry companies—including major credit bureaus—that provide services to help identify, verify identity of or locate individuals. It's the main lobbying front for the credit industry. In May 2001 congressional testimony, the IRSG's Ronald Plesser made the industry's case:

The members of the IRSG are committed to the responsible acquisition and use of personally identifiable information in business-to-business transactions. We do not oppose a prohibition of the public display of Social Security numbers to the public. We share the Committee's concern about the potential misuse of SSNs for identity theft and other harmful purposes.

We do oppose legislation that would prohibit the purchase and sale of SSNs for legitimate business purposes.

In the fight against identity theft, where verifying an individual's identity is crucial, individual reference service products are absolutely essential. Banks, credit card companies and other types of credit institutions…are all becoming increasingly plagued by fraudsters who use an existing person's identity to illegally obtain products, services and money. The best, and perhaps only, means of preventing this type of fraud is to crosscheck through the use of personal identifying data, often provided by individual reference services.

DOES SELF-REGULATION WORK?

In July 2001 congressional testimony, John A. Ford—the Chief Privacy Officer at Equifax, Inc.—defended his company's commercial use of SSNs:

[T]he personally identifiable information in our consumer-reporting database is entirely separate and distinct from information contained in our marketing databases. In fact, the databases are managed by totally separate Equifax companies.

Naturally, marketers must have name and address information in order to communicate their offers directly to consumers. It is important to note, however, that the information included within the Equifax market-

ing databases is not organized so as to be readily and easily retrievable by personal identifiers (i.e., name and address).

It is very important to emphasize that personal information obtained for marketing purposes is not used for risk assessment purposes. Marketing data is not used to make decisions about whether an individual obtains or retains a job, insurance or a government license or benefit. Instead, the information is used merely for the purpose of efficiently shaping the kinds of offers an individual receives.

[O]ur customers are prohibited from using our marketing databases for individual look-up purposes. We have always contractually prohibited our customers from using our database for this purpose. Furthermore, we have designed our system so that we have no delivery mechanism for a customer to query the database based on a name; therefore, no individual look up is offered or feasible.

Further, Equifax provides consumers with meaningful and practicable privacy protections through our compliance with a variety of self-regulatory programs providing consumer rights and redress.

Legitimate business access to relevant consumer information is critical to achieving a number of societal benefits: thwarting identity theft, locating estate heirs, witnesses, child support delinquents, debtors, missing children, organ donors, etc.

Consumer advocates scoff at the **tactic of defending the sale of personal financial information** behind missing children and organ donors.

In the era of financial services consolidation, the ties between credit bureaus and direct marketing companies are getting closer. In fact, some credit bureaus *are becoming* direct marketers. For example: Equifax provides consumer information to banks and lenders making credit decisions. These activities are regulated under the Fair Credit Reporting Act and dozens of state statutes. But Equifax Direct Marketing Solutions—a corporate sibling acquired in the 1990s—maintains "the largest marketing database of lifestyle and compiled data in the world." And Equifax makes this information available to **anyone who will pay for it**.

Does this mean Equifax is selling personal financial information like SSNs? Yes, in some cases.

Not everyone agrees that private-sector companies should be free to sell personal information that includes SSNs—even if the buyers have "legitimate business purposes." In May 2001 congressional testimony, Marc Rotenberg—Executive Director of the Electronic Privacy Information Center—made the case against the credit bureaus' sale of personal information:

> Several years ago, significant public concern was raised about information brokers that routinely buy and sell detailed personal information, including Social Security numbers. The Individual Reference Services Group was established to improve practices

in the industry. We do not believe these principles provide sufficient safeguards for consumers.

IRSG companies gather and sell Social Security numbers. Social Security numbers are collected from a variety of public and nonpublic sources. Public documents such as bankruptcy filings and other types of court records often contain Social Security numbers of the parties to a proceeding. Nonpublic documents such as credit headers, the identifying information at the top of credit reports (including names, addresses, ages and SSNs), are also culled for information.

Rotenberg also pointed out that, in 1997, the IRSG had worked with the FTC—but without any public input—to develop a set of self-regulatory principles. These self-regulatory principles allowed for the sale of SSNs without the knowledge or permission of the people to whom the numbers refer.

Under the IRSG principles, companies can freely sell and distribute **SSNs gathered from public records**. The IRSG Principles treat SSNs differently if they come from non-public sources—such as other credit bureaus. However, the guidelines for the sale of SSNs from non-public sources are completely subjective and largely ignore the privacy interests of the people involved.

The IRSG principles create a multi-tier system for the sale of information gathered from non-public sources. The first tier for the sale of SSNs applies to "qualified subscribers"; complete SSNs can be sold to those deemed to fall into this category. But there's no defi-

nition of what makes someone a "qualified sub-
scriber." Moreover, the conditions that qualified sub-
scribers must meet under the IRSG principles rely
entirely on the determination of the data seller and
the data purchaser on what is an "appropriate" use
of such information. The person whose SSN is be-
ing sold has no input into whether the use is "appro-
priate."

Rotenberg went on to describe IRSG self-regulation:

> Oversight of IRSG companies is generally
> weak. Yearly assessments required by the
> IRSG Principles, are conducted by "reason-
> ably qualified independent professional" ser-
> vices. The assessment criteria, in many places,
> simply ask whether IRSG companies have
> some process in place, rather than evaluating
> whether such a process is effective. The as-
> sessment criteria do not seek to evaluate
> whether such qualifications are stringent
> enough or even if they are evenly applied
> among different IRSG companies. In addi-
> tion, none of the results of assessments are
> publicly displayed.

Rotenberg's group suggested that Congress enact leg-
islation that would:

- limit the use of the SSN to those cir-
 cumstances where use is explicitly autho-
 rized by law;

- **prohibit the sale** and limit the display
 of the SSN by government agencies;

- prevent companies from compelling
 consumers to disclose their SSN as a con-

dition of service or sale unless there is a statutory basis for the request;

- penalize the fraudulent use of another person's SSN but not the use of an SSN that is not associated with an actual individual. This would permit, for example, a person to provide a number such as "123-00-6789" where there is no intent to commit fraud; and

- encourage the **development of alternative, less intrusive means of identification**.

PRIVACY NOTICES

We started this chapter by discussing the Gramm-Leach-Bliley Act of 1999 and its effect on consolidation in the financial services industry. But the GLB Act also included a number of consumer-protection measures which—if used correctly—can be of real help in combatting ID theft.

The GLB Act requires organizations that gather personal information from customers to **mail notices each year** explaining how the groups use the information. It applies to a wide variety of operations, including obvious ones like banks and credit card issuers. But it also applies to less-obvious ones—insurers, automobile dealerships that arrange financing or leasing and financial advisers and consumer counseling agencies.

Each must report to its clients—whether it sells the information or gives it to other organizations—and

explain **how consumers can opt out** of having at least some of their information distributed. These written notices must clearly describe the institution's practices and policies about collecting and sharing "nonpublic personal information." For example, a typical disclosure might explain that your bank shares information about your account balance, payment history and credit card purchases with non-financial companies, such as retailers, direct marketers and publishers.

A critical provision of the law gives consumers the right to **block an institution's disclosure** of private information to companies not affiliated with that institution. Under the rules, even people who are not technically customers of a financial institution—such as former customers or people who applied for but didn't obtain a loan or credit card—will have the right to opt out of information sharing with outside companies.

Note that only *some* of the information releases can be blocked.

CONCLUSION

In the interest of keeping commerce moving and allowing institutions to know who they do business with, the GLB allows them to share certain information. This includes information about customer accounts to organizations that promote the company and its products. It includes information provided in response to a court order. It also includes **payment histories** on loans and credit cards provided to credit bureaus. Finally, it includes **transaction records**—including

loan payments, credit card purchases and checking and savings account statements—to organizations that provide its data processing and mailing services.

The rules were issued jointly by the FDIC, the Office of the Comptroller of the Currency, the Federal Reserve Board and the Office of Thrift Supervision. The National Credit Union Administration, the FTC and the Securities and Exchange Commission have comparable rules for the institutions and companies they regulate that provide financial products or services. Under the FTC's rule, for example, credit bureaus are **limited in their ability** to sell non-public personal information to third parties such as direct mail and telemarketing companies.

More detailed information about the mailings and what to do about them is available on the FTC Web site at *www.ftc.gov*. A copy of the FTC's **sample opt-out letter** that consumers can send to credit bureaus to prevent some distribution of their data is included there.

The ability to opt out of marketing mailings—like the ability to opt out of direct marketing phone calls, also administered by the FTC—is an essential part of fighting ID theft.

Until regulations restrict the credit bureaus' and other financial institutions' active marketing of personal information, opting out is the best option you have.

CHAPTER 8

PREVENTION

Due to the nature of identity theft (how easy it is to commit when no one is looking), preventing identity theft **starts with the consumer**. Even when law enforcement agencies catch up to addressing the problem, it will still be up to you to prevent the majority of the crimes.

> Because ID thieves are opportunistic, some basic preventive measures can do a lot to dissuade. Prevention starts with deterrence, much like using an alarm or The Club on your car. Either of these anti-theft devices can be surpassed, but real deterrence comes from making your car a little tougher to steal...so that the thief will move on to the next one.

The world is too large, transactions are too quick and easy to make, and the volume of information passed back and forth is too dense for anyone to prevent all ID theft. Accept ID theft as a negative **by-product of our modern technology**—like spam, computer

viruses and other nuisances that get traded when you **swap security for convenience**.

There are two other big burdens you must come to accept:

1) It's up to you to safeguard your personal information; and

2) It's up to you to report any illegal activity to the proper authorities and agencies. Unfortunately, no one is going to call you the minute someone starts opening accounts or making large purchases in your name.

No one is going to save your reputation and credit history when it runs amok and requires time, money and energy to repair it. No one can afford to have the "It can't happen to me" mentality. We've seen how anyone's identity can get stolen and grossly misused. In this chapter, we'll outline the only way to avoid the hassle of losing your identity: **prevention**.

None of these preventive tactics guarantees that you won't become a victim of identity theft. But they will lower your overall risk—especially when used together.

> The more locks you have on your doors, the less of a chance a burglar will come into your home and steal from you. Likewise, when it comes to ID theft, the goal is to lessen the number of opportunities a potential thief has to impersonate you.

YOUR SOCIAL SECURITY CARD

We've already seen how vital it is to **protect your Social Security card**. Are you still schlepping it around in your wallet or purse? It's time to take an inventory of your Social Security numbers lying around and eliminate all chances for its disclosure. Remove it from your wallet (if it's still in there) and keep it in a safe place at home, such as a fireproof box where you keep other important documents. Don't write your number on a slip of paper to be kept in your wallet, either. If you haven't done so by now, **memorize your Social Security number** and avoid all extra recordings of it.

As many jurisdictions and counties go online and attempt to post public records online, you must worry about records that contain your SSN.

Records have always been available for the public to view on microfilm rolls at the courthouse, but some new laws make those records even more accessible online. Title companies can research deeds from their office computers; and homeowners can look into a lien or judgment without going to the courthouse.

Public **access to electronic records** will continue to broaden. It's up to you to know what public records contain information about you, and whether those documents can get into anyone's hands. Many counties are not diligent in **separating public from confidential** documents in their computer databases. Until

courts adopt policies that comply with the rules, there's no telling what will end up on the Internet.

> **If you've ever bought or sold a piece of property, served in the military or been involved in a court judgment, a valuable piece of your identity could soon find its way onto the Internet: Your Social Security number. Voter registration cards and marriage certificates can also contain such information.**

You can't prevent local courts from posting information. But you can check these postings online for any references to you. And—since most courts honor requests to edit or obscure personal details—you can ask them to cut out your detailed information. (This cutting is sometimes called *redicting*.)

Never provide your SSN, or any other personal information for that matter, when it's not necessary. Product manufacturers don't need to know your occupation. The health club does not need your SSN. Only the **government or a lender** should be asking for Social Security numbers. Never have your Social Security number printed on your checks—you can write it in if necessary

> **California state law now says Social Security numbers may not be openly displayed on things like health forms, bank account records or anything sent in the mail. Other states are following this lead.**

Many people have been duped by swindlers who pretend to be from the IRS. When someone claims to work for the Internal Revenue Service and starts firing sensitive questions at you, do a little homework before answering. Be **wary of first-time calls** or surprise visits from someone you've never heard from before. If the IRS needs to conduct business with you (e.g., you've underpaid in taxes), you should receive a letter from the IRS before hearing directly from an agent.

In some cases, IRS criminal investigators may show up without prior warning, or they may try contacting you without having sent a letter first, but you can ascertain their legitimacy by asking for the **employee's name, badge number and supervisor's name**. If they're legitimate, they shouldn't mind your calling their office to verify their identity. And, they won't be asking for your SSN—they'll already have it.

> Best way to handle an alleged IRS agent: Pass the trouble on to a tax adviser, such as a lawyer, accountant or "enrolled agent," a tax professional licensed to represent you at the IRS. If you're still not satisfied by the investigator's credentials, or have some reasonable basis for your suspicions, call (800) 366-4484. Or write to: Treasury Inspector General for Tax Administration, PO Box 589, Ben Franklin Station, Washington D.C. 20044-0589. TIGTA says the information you provide is kept confidential, and you may remain anonymous.

DETECTING SSN MISUSE

Currently, federal law places no restrictions on the use of the SSN by the private sector. People may be asked for an SSN for such things as renting a video, getting medical services, joining a gym and applying for public utilities. If you refuse to give it, you might not be able to get the product or service.

One way that you can find out whether someone is misusing your number is to check your earnings records. About three months before your birthday, anyone **25 or older** and not already receiving Social Security benefits, automatically receives a Social Security statement each year. The statement lists earnings posted to your Social Security record as well as providing an estimate of benefits and other Social Security facts about the program. If there is a mistake in the earnings posted, you are asked to contact the SSA so your record can be corrected. The SSA investigates, corrects the earnings record and if appropriate, it refers any suspected misuse of an SSN to the appropriate authorities.

Order your **Social Security Earnings and Benefits Statement** once a year to check for fraud. You can order the statement by calling (800) 772-1213.

The SSA may learn about misused SSNs in a variety of other ways—including alerts from their computer systems while matching federal and state data, processing wages, claims or post entitlement actions, reports from individuals contacting its field offices or teleservice centers and inquiries from the IRS con-

> cerning two or more individuals with the same SSN
> on their income tax returns.

If your Social Security number has been used fraudu-lently, call the SSA's Fraud Hotline, (800) 269-0271. In extreme cases of fraud, it may be possible for you to get a new number.

OTHER ITEMS IN YOUR WALLET

What else is in your wallet? If you were to lose your wallet today, there's probably a lot to worry about.

Place the contents of your **wallet on a photocopy machine**. Copy both sides of each license, credit card, etc. This way you will know what you had in your wallet should it get lost or stolen. You will have all of the account numbers and phone numbers to call and cancel. Keep the photocopy in a safe place. Other-wise, you may give someone your entire identity in one neat package.

Along with leaving out your SSN, dump bank ac-count numbers, personal identification numbers (PINs), passports and birth certificates. Leave those in a **fireproof box at home**—never in your wallet. Don't carry more blank checks than you need in your wallet, either. If your SSN is on your driver's license, ask your state for a new number and license (if pos-sible).

Quick Tips

- Never leave your purse or wallet unattended in public or in open view in your car.

- Keep checks in a secure place and destroy them when you close a checking account.

- Never give credit card, bank or Social Security information over the telephone.

- Minimize exposure of your Social Security number.

- Safeguard your credit, debit and ATM card receipts and shred them before disposing of them.

- Check your **utility and subscription bills** to make sure the charges are yours.

- **Memorize your passwords** and personal identification numbers and don't keep them near your credit cards.

- Keep a list of, or copy, all credit and identification cards you carry so you can quickly call the issuers to inform them about missing or stolen cards.

- A form to stop credit and insurance offers from being sent to you is available at *www.ag.state.mi.us/cp/cp_form02.pdf*

- A form to remove your name from telephone and mailing lists is available at *www.dmaconsumers.org/privacy.html.*

HANDLING CREDIT CARDS

Cancel any credit cards you don't really need or use; open credit is a prime target. Keep **good back-up information** about your accounts, just in case your wallet is lost or stolen. Consider using a service to handle replacement of cards, provide fraud liability protection and deliver expert advice on protecting yourself and your credit following a loss or theft (more on this later). If you ever need to give personal information out over the phone, ensure the person on the other end of the line is well-known and trusted. You should have initiated the call. Avoid providing personal information when using a check or plastic for purchases at a cash register.

Before offering a company any personal data, ask how it will be used and whether any of it will be shared with third parties. If you're unsure who's called you, ask for their number—so you can call them back at the company's office. A law passed in 1999 permits financial institutions to sell or aggregate your data unless you expressly ask them not to do so—usually by choosing the "opt-out" selection on your print or online forms. After opting out, follow up to make sure the company honors your request.

Shred credit card applications you receive in the mail along with bank statements, 401(k), stock and mutual fund statements and any other financial documents.

Review your credit card bills and your checking account statements as soon as they arrive, to ensure that no fraudulent activity is taking place. If a statement does not arrive, that could be a sign that someone has changed your billing address for fraudulent purposes.

Retain all **duplicates of your receipts** when making a purchase and retain receipts from ATM withdrawals. Do not put your credit card account number on checks used to pay your monthly bills. The credit card agency can always trace your check through your name/address information from your check.

When applying for a credit card, **check the return address**. If there is a sticker with a return address placed on the application, contact the card issuing company to verify the correct address.

> Take care how you dispose of receipts, copies of a credit application, insurance forms, bank checks, brokerage statements and unsolicited credit offers. Consider shredding them before leaving them in the trash. Do not write your card number on a postcard notifying you that you have won a prize or gift and requesting the number as part of the award arrangements. Do not leave gasoline credit card receipts at the pump.

No federal law requires merchants to block out credit card numbers, although Congress is considering legislation. One bill would ban the printing of more than the **card's last five numbers** on a cardholder's receipt. Printing the expiration date also would be pro-

hibited. About 10 states already have enacted truncation laws, including Arizona, Washington, Missouri and California.

More Quick Tips

- Don't give your checking account number to people you don't know, even if they claim they are from your bank.

- Reveal checking account information only to businesses you know to be reputable.

- Report lost or stolen checks immediately.

- Properly store or dispose of cancelled checks and **guard new checks**.

- Report any inquiries or suspicious behavior to your banker who will take measures to protect your account and notify proper authorities.

- Do not leave your automated teller machine receipt at the ATM; it contains account information.

- Check your bank statements carefully and often.

- Use **direct deposit** (if possible).

The next time you order pre-printed checks, only have your initials, instead of your full name, printed on the checks. If someone takes your checkbook, they will not know if you sign your checks with just your initials or your full name. But your bank will know how

you sign them. Don't have your phone number printed on your checks.

If you have a P.O. Box, have that address printed on the checks. If you work, you might want to use your employment address. Otherwise, it would be safer not to have a pre-printed address on the checks.

CNN weather person Orelon Sidney ordered a box of checks that he never got. Then the company sent out a second box of checks that he did get—but the first box had been intercepted and soon enough, Sidney started seeing checks clearing for $1,000 and $600 and $900. It not only took Sidney a long time to realize the problem, but correcting the issue with the bank, the credit bureaus and the collection agencies after him took a long time.

Avoid this scenario by always **picking up new boxes of checks** at your bank.

REVIEWING CREDIT REPORTS

Review your credit reports from each of the three national credit reporting agencies at least twice a year. You are entitled to a free copy of your credit report if you are unemployed, on welfare, were recently denied credit or if your report is inaccurate because of fraud. (Otherwise, there is a small fee.) In addition to your debts and payment history, credit reporting agencies also provide: general data (name, SSN, marital status, addresses—past and present); employer's name and address; inquiries of your credit file; and public record information like bankruptcies and liens.

> Credit reporting agencies do not, however, maintain files regarding your race, religion, medical history or criminal record—if you have one.

Review your report carefully to make sure no unauthorized charges were made on your existing accounts and that no fraudulent accounts or loans were established in your name. Unfortunately, credit agencies and FICO scores, respond slowly to remedy credit rating effects of ID theft. This is where most of the **lasting damage** happens.

Below, you'll find the information you need to access all three major credit bureaus.

The Big Three Credit Bureaus:

Equifax (*www.equifax.com*)

- To dispute information in your report, write to: Equifax Service Center ATTN: Dispute Department, P.O. Box 740256, Atlanta, GA 30374.

- To order a credit report, call: (800) 685-1111

- Or mail: P.O. Box 470241, Atlanta, GA 30374 ATTN: Disclosure Department.

- To remove your name from pre-approved offers of credit and marketing lists, call (888) 567-8688 or write to: Equifax Options, P.O. Box 740123, Atlanta, GA 30374-0123.

Experian (*www.experian.com*)

- To order a credit report, call: (888) 397-3742.

- Or write to: P.O. Box 9066, Allen, TX 75013.

- To dispute information in your report, call (800) 493-1058 or write to: P.O. Box 9556, Allen, TX 75013.

- To remove your name from pre-approved offers of credit cards, call (800) 567-8688. To remove your name from marketing lists, call (800) 407-1088.

TransUnion (*www.tuc.com*)

- To order a credit report, call: (800) 916-8800

- Or write to: Trans Union LLC, Consumer Disclosure Center, P.O. Box 1000, Chester, PA 19022.

- To dispute information in your report, call: (800) 916-8800.

- To have your name removed from pre-approved offers of credit and marketing lists, call (888) 567-8688 or write to: Trans Union LLC's Name Removal Option, P.O. Box 97328, Jackson, MS 39288-7328.

INSURANCE AND SERVICES

In 2002, federal prosecutors charged three men with operating an identity-theft ring that had stolen credit reports of more than 30,000 people—the largest case in history. The defendants include a computer help-desk employee at a Long Island software outfit who had access to sensitive passwords for banks and credit companies. The ring allegedly emptied bank accounts, took out loans with stolen identities and ran up fraudulent charges on credit cards.

Most of the damage could easily have been prevented if the credit agencies adopted the common-sense practice of directly notifying individuals whenever a change on his or her report occurs, and whenever a third party accesses their credit report. But they don't.

Because ID theft has become a well-known problem, companies are responding by offering insurance to ease the burden. **Identity-theft services** from the credit card agencies and bureaus is also a burgeoning business.

Travelers Insurance of Hartford, Conn., first offered an identity-theft policy in 1999. Other insurance companies have followed, adding coverage to their basic homeowners policies or as riders. ID theft coverage pays for the time and money it takes you to complete the logistical and legal paperwork. This can include lost wages, notary public fees, Federal Express or other kinds of packaging and mailing. In some instances, legal expenses can be covered.

Check your **current policies for existing coverage**, as a homeowners or renters insurance policy might already contain some coverage. If you want coverage, ask your current insurance company for information about adding coverage to existing policies, or if you need to purchase a stand alone policy. Travelers insurance, for example, sells stand alone policies from $59 to $180 a year.

You might also be able to find coverage through your credit card companies, bank or employer. An employer can purchase coverage under a legal insurance policy and you pay the premium out of your paycheck.

> Having coverage for ID theft won't protect you from the problem in the first place. It will only help you once it has happened. So, on one level it offers peace of mind...but you don't want to have to use it. The laws against ID theft and the insurance you can buy will be less effective in the long-run than the simple preventive measures you can take to avoid the crime altogether.

When shopping for this kind of insurance, look for:

- price;
- content (what expense will be covered); and
- overlay (whether you already have coverage elsewhere).

CREDIT MONITORING SERVICES

Insurance companies also have been partnering with credit management and monitoring agencies to provide new services to consumers—but at a cost. For example, ING Direct has partnered with Privista to give customers, among other things, online access to weekly credit reports using Equifax credit data, weekly updated credit scores and personalized tips to improve your credit.

These services can cost between $30 to more than $100 a year. Equifax has teamed up with the insurer American International Group (AIG) to offer specialized insurance. Equifax's Credit Watch product promises to send alerts to consumers via e-mail or letter within 24 hours after something pops up on their credit report. The company will also reimburse you up to $2,500 in identity theft costs.

> The same companies that record your credit histories and market your good name and reputation also sell services so you can protect your credit.

It's important that you make sure that the monitoring service you choose or try out **delivers data in a useful format**. Consumers should not have to pay to have their credit reports monitored, but until legislation changes the mechanics behind reporting, marketing and monitoring people's credit reports, you have to decide how much you're willing to pay for services. Be wary of how these programs are promoted: many offer "free" services of one month,

then will gladly charge you $80 for the year if you forget to call and cancel.

> The cheapest route for consumers is to see what protection services your credit card issuers offer at no charge. Bank of America, for example, started advertising its Total Security Protection program to people who get their credit cards through the bank.

Bank of America's program draws from services the big consumer bank already offers: exempting the customer from liability for unauthorized charges and account monitoring for unusual activity. Discover, another card company, offers customers free cards with "perishable" (one-time only) account numbers for making online purchases.

> Many of the credit watch services only monitor one of the three major credit bureaus. As with anything, make sure you know what you're getting before you buy. Check out any company you're not familiar with before doing business with them. Contact your local consumer protection agency or the Better Business Bureau to find out if they have any complaints on file.

Online services are also cropping up to help you monitor your personal information. Cardcops (*www.cardcops.com*), for example, gathers up credit card numbers in cyberspace from public areas. Where do

they find them? In chat rooms, search engines (have you ever Googled your credit card number?), on merchants' Web sites that accidentally post customer orders and credit card numbers. Cardcops takes the numbers it finds and puts them into a database that you can access and see if your personal information is floating out there in cyberspace.

BIOMETRICS

You might soon find yourself swiping your fingerprint instead of your check card when you go to the market for milk. Biometric technology (which identifies an individual by a physical attribute, such as the sound of his or her voice, or recognition of eyes, face or even DNA) is closer than you think. Within the next five years, biometric checkout lanes could be standard. Fast-food giant McDonald's has already taken fingerprints for payment during a test in Fresno, California.

> The biometrics market is still in a curious state of anticipation as multiple government agencies mull what will work best for everything from passports to drivers' licenses. At the same time, civil liberties groups and privacy advocates are urging caution.

At three of its grocery stores in Texas, Kroger uses technology that lets consumers scan their fingerprints at the checkout counter. Once the system recognizes the shopper, it charges their purchases to a designated credit card or checking account.

If given the opportunity to use a biometric system at the market or bank, consider accepting it. Most banking and security experts predict that fingerprint, hand, iris or facial recognition will become widely used in the 2000s. Fingerprint biometrics are already used to check welfare eligibility in California, Texas and New York, and some governments—the Philippines, Argentina, Hong Kong—are creating national ID programs with the technology. And dozens of Fortune 500 companies already use fingerprint scans for network or PC access.

TIPS FOR BUSINESSES

The focus of this book has been on what consumers can do to prevent ID theft. But it's worth mentioning a few tips for businesses, since many consumers are running small businesses themselves and need to prevent ID theft in their personal life by changing their work setting habits. Some tips:

- Review your bank statements regularly, and ensure that the **authorized signers** are not the same people who reconcile the account.

- Have Social Security, and as many other checks as possible, deposited directly into your bank account rather than mailed to you.

- Review all **hiring procedures**. Know your employees. Consider background checks.

- Make sure two people are responsible for accounts payable, and ensure that mailroom personnel and procedures are sound.

- Keep all check stock or cash equivalents in a secure and locked facility.

- Change **keys, entry codes and passwords** periodically to prevent routine access to storage areas and computers.

- Consider **surprise audits of your own accounts**.

- Consider moving check disbursement activity to electronic payment.

- Read and understand your bank contracts regarding liability for fraud under the Uniform Commercial Code.

- Maintain **contact with other businesses** in your area so you can receive timely information on fraud occurrences.

- Use bank services like positive pay, expedited return information and signature verification systems to protect your accounts payable and accounts receivable areas.

- Purchase **check stock from well-established vendors**. If you process your payables through a service bureau, make sure you have a copy of its security procedures.

- Reconcile your check disbursements and deposits regularly.

- If a payment account is fraudulently used, close the account as soon as possible.

- Be cautious when using refund accounts, such as rebates for subscriptions. This is another target for check fraud. The

checks are relatively easy to obtain and can be used for counterfeits.

- Evaluate the use of **negative check file databases**, especially if you accept a large number of payments by check.

- Find ways to replace paper documents with electronic payment devices.

- **Know your customers**.

In the normal course of the day, staff members will be working with sensitive information. They should take care not to leave papers, forms, reports and so on out at their workstations—especially if the area is not completely secured. Even seemingly harmless documents can be used against the company and employ.

Employees who work in the human resources, payroll and benefits departments are commonly bound by specific rules that govern their access to information and that include termination penalties for violating their employers' confidentiality policies. Make sure they understand these rules—and that the rules will be enforced.

CONCLUSION

A lot of prevention has to do with making **lifestyle changes**. It's about how you manage your mail, financial records and bank accounts, pay bills, use your credit cards, use the Internet…and even pick topics of conversation at a cocktail party.

The next chapter is more of an extension of this chapter. It deals with ways of preventing identity theft via

the changes you make to your daily life. You'll find that a major joint of access to your identity involves the Internet, so you'll find some techniques to implement when you're online, whether you're in a community chat room or on a merchant's site ready to buy.

CHAPTER 9

LIFESTYLE
CHANGES

It's hard to know these days which way is the "safer" way to pay for something with a credit card: online with a known vendor or over the phone with an equally well-known merchant? Can a phone line's security be compromised as easily as an online transaction?

Trouble is, no one knows. It's hard to know when and where a **breach in your personal security** will occur.

> The most secure way to pay for something is with cash. But few people resort to carrying cold hard cash in their wallets—not because they fear being mugged, but because it's not as convenient or they just don't have it (i.e., they buy on credit).

Many of the conveniences we enjoy today result in a relinquishment of security on some level. For example, you can use a debit card instead of writing a check when you go to the supermarket; you can make pur-

chases from the **comforts of your home** on the Internet with a credit card; and you can sit on a public bench in a public park and log onto the Internet using a wireless network set up for people like you who use your lunch hour to write e-mails and **hotsink critical information** to and from your PDA.

For purposes of safeguarding your identity, would you be willing to make changes to your lifestyle that may be inconvenient in today's world? Ask yourself:

- Can I get rid of the extra credit cards? All of them?

- Can I find a system of passwords rather than resorting to the same old password?

- Can I organize my financial records and shred everything I don't need that contains my personal information?

- Can I resist online commerce?

- Can I change the way I pay bills, use mail and discard unwanted material?

How you answer these questions says something about how serious you regard your identity…and **how dedicated you are** at protecting that identity.

WHEN YOU'RE ONLINE

The Internet provides a huge window of opportunity for criminals. With the easy availability of family Web pages on the Internet, be cautious about the kind of **information you post** there.

Posting pictures of the inside of your home on the Internet for friends and family to see might seem like

fun, but the photos give a thief a road-map of what type of valuables are in your home and where they're located. **Do not**:

- post the itinerary for your upcoming vacation;

- post information or photos about collectibles;

- post family information, names, favorite places, memories or something about your heritage;

- post information about your child, such as his or her age, photos, after-school activities, friends or hang-outs; or

- post your address, place of business, family names or information about who you do business with.

The key to **noticing a secure Web site** is in the URL. When you log on to a Web site, take a look at where you see the "http" in the address, after which there will be a semicolon. If you're on a site that's supposed to be secure, such as a place where you make actual purchases and input personal information, you'll see an "s" pop up after the "http." For example, when you go into *Amazon.com* and you're starting to buy something, it's going to say "https" at the very top in that URL page.

You can also go to something called *www.bizrate.com*, a Web site that displays **e-business ratings** by consumers.

> Make sure every Web site you patronize has a toll-free number, which gives you the ability or the opportunity to call in your order. Any good, legitimate outfit will offer a number (many of them toll-free) on the home page, giving you the option of ordering over the phone.

Another good tactic: Only **use one credit card** when shopping online. Designate one card for making your online purchases.

Internet criminals often use unsolicited commercial e-mail, known as "spam," to commit Internet fraud and identity theft. Spam can be used to target unsuspecting consumers and lure them to official looking Webs sites—such as a billing center for an online service provider or the front page of a mortgage information form. When users enter passwords, SSNs or credit card information, the information may be taken and used or sold by identity thieves. To prevent being duped in this fashion, practice the following 10 things:

1) Never purchase spam-advertised products.

2) Always protect your personal information—assume that anything online may become public.

3) Never send personal information to e-mail requests. (You should never be asked for a password, credit card number or SSN from a legitimate source via e-mail.)

4) Verify every transaction.

5) Beware of **get rich quick schemes**.

6) Never pay "up front" for loans or credit. Legitimate lenders generally do not "guarantee" a loan or credit card before you apply.

7) Refrain from clicking on Reply or Remove. Some senders may remove your address, but others may flag your e-mail address as "live," and send you more spam or even sell the address to other spammers. Instead, forward spam to the FTC at *uce@ftc.gov*.

8) Use a "public" e-mail address when online. Set up and use a **public e-mail address**—either an additional address from your ISP or a free e-mail address. Use this e-mail address when participating in newsgroups, joining contests or anytime that your e-mail is requested by a third party online. Potential spam will go to your public e-mail address instead of your private e-mail address.

9) Don't post your e-mail address online. You'd be surprised how often you use your e-mail address online for newsletter subscriptions, to join online groups or in chat rooms. Before you post your e-mail address, know whether it will be displayed or used. Then use a public e-mail address when necessary.

10) Use an **e-mail filter** to help eliminate unwanted e-mail.

LOOK-ALIKE E-MAIL SCAMS

As mentioned before, one of the ways ID thieves get your information is by "pretexting" or simply giving up your information to someone who is pretending to be someone important. This can happen easily over the phone ("Hi, I'm calling from Verizon with some questions about your account because there seems to be a problem…") but it can also come in the form of an e-mail that looks real in the sense that it **contains company logos** and links back to the legitimate company's site.

> **You might get an e-mail from "eBay" that asks you to click on a link to verify your account information, which then takes you to a criminal's Web page…and a few clicks later, your personal data is in the hands of an identity thief.**

This is called "phishing," and it involves **stealing a company's identity** to use in a scam for victimizing consumers, then stealing their credit identities. These e-mails usually contain a threat designed to trick consumers into entering their information (e.g., "We regret to inform you that your eBay account will be suspended. According to our site policy, you will have to confirm that you are the real owner of the eBay account by completing the following form or else your account will be deleted.") Another that went around the Internet came from Microsoft Network (MSN):

We regret to inform you that technical difficulties arose with our July 2003 updates. Un-

fortunately, part of our customer database, and back-up system became inactive. We will require you to enter your information in our online billing center at your convenience. Or by calling our customer support team. The average hold time is 45 minutes.

Never reply to such e-mails. Legitimate companies don't usually ask for this kind of personal financial data over e-mail. Be wary of e-mails that urge you to click on a link to a Web page that asks for financial information. Links appearing in **HTML-based e-mails** cannot be trusted because programmers can easily make a link to a criminal's page look like a harmless link to a site like *eBay.com* or *PayPal.com*.

Tips for avoiding scams of this kind:

- If you get an e-mail that warns you, with little or no notice, that an account of yours will be shut down unless you re-confirm your billing information, do not reply or click on the link in the e-mail. Instead, **contact the company** cited in the e-mail using a telephone number or Web site address you know to be genuine.

- Avoid e-mailing personal and financial information. Before submitting financial information through a Web site, look for the "lock" icon on the browser's status bar. It signals that your information is secure during transmission.

- Review credit card and bank account statements as soon as you get them and

look for unauthorized charges. Know when all of your **closing dates on your cards** are, and if your statement is late by more than a couple of days, call your credit card company or bank to confirm your billing address and account balances.

- Report all suspicious activity to the FTC.

Visit *www.ftc.gov/spam* to learn other ways to avoid e-mail scams and deal with deceptive spam. The FTC works for the consumer to prevent fraudulent, deceptive and unfair business practices in the marketplace and to provide information to help consumers spot, stop and avoid them.

A WORD ABOUT PASSWORDS

If you were to tally up **how many passwords** and PINs you currently have, you probably have more than one. You *should* have many more than one. Between the codes you need to access your bank accounts, you have ones for your computers, e-mail accounts, voice mailboxes, cell phones, debit card, credit cards, online subscriptions, online Web sites, online banking, online financial accounts (e.g., investing), various memberships to clubs, frequent flyer programs, merchants, etc. The list goes on and on.

Because everything we sign up for today often requires a password or code, it's no surprise that many of us use the **same old password** for multiple purposes. The one we use at the ATM is the same one we use to log into the New York *Times* or *msn.com*.

Having the same password across the board is not the safest thing to do. Someone can probably figure out that password if he or she worked hard enough.

> **The goal: Use a system of passwords. Do not use the same old password for everything. Get crafty.**

Place *different* passwords on your credit card, bank and phone accounts. Avoid using easily available information like your mother's maiden name, your birth date, the last four digits of your Social Security number, or your phone number or a series of consecutive numbers. When opening new accounts, you may find that many businesses still have a line on their applications for your **mother's maiden name**. Use a password instead.

Tips to Creating a Good, Secure Password

- The trick: creating a word you can remember, but someone else can't guess.

- Use at least seven characters, including upper and lower case letters, numbers and symbols.

- Use at least one symbol character in the second through sixth position.

- Use at least four different characters in your password (no repeats).

- Use a sequence of random letters and numbers.

- Avoid any part of your name, business logo, birth date, mother's maiden name, etc.

- Avoid any actual word or name in any language.

- Avoid using numbers in place of letters.

- Avoid reusing any portion of an old password.

- Avoid using consecutive letters (i.e., abcdefg) or numbers (i.e., 4567).

- Avoid using adjacent keys on the keyboard (i.e., asdfjkl).

The trick is to create a word you can remember, but that someone else can't guess. Fun note: the most popular password is "PASSWORD" so avoid that word at all costs.

Other notes about passwords:

- Create **tricky passwords** for protecting very important information or for any online transaction where you credit is at stake (i.e., shopping, banking, mutual funds, brokerage, investment retirement accounts, money management software, tax preparation software, auctions, insurance, etc.).

- Create **simple passwords** for accessing less critical information like online magazines, newspapers, chat rooms, etc.).

- Avoid the "Remember my password" feature on most sites, unless you know those sites are secure.

- Avoid sharing your password or writing it down (and sticking it to your monitor!).

- Change passwords **every six months**.

Monitoring Your Online Accounts

- Review your accounts online frequently to spot transactions you didn't authorize, such as online credit card charges, mutual fund transfers, bank account withdrawals, etc.

- Review **monthly statements** you receive in the mail for unauthorized activity.

- Call an account if you don't receive a monthly statement in the mail.

- Get a credit check annually to see if anyone has opened a new account in your name.

How would you know if someone stole your password and began using it to pretend to be you for various reasons on- and offline?

You'll only know for sure if you spot unusual activity in your accounts or if you don't receive a monthly bill or bank statement. If an identity thief changes the mailing address for your accounts, you may not know you have a problem until you get a phone call from a collections agency…or you apply for a mortgage and get denied.

Think of your password as a **key to your home** and everything you own—including your credit and ultimately, your reputation.

Things to Consider When Making Online Purchases

- Check **seals of approval links** to verify merchants' authenticity (e.g., TrustE, BBBOnline, BizRate, etc.);

- Call companies on the phone to judge their legitimacy;

- Read privacy policies;

- Verify electronic security protocols;

- Know what a merchant will do with your personal information;

- Know how to tell when a transaction gets encrypted (i.e., before you enter a credit card or personal information, look for "**https**" instead of "http" in the address bar and for the "lock" icon at the bottom of your browser; and

- Check you monthly statements for transactions that don't look familiar.

Online Activities to Avoid

- Auctions;

- Financial transactions (trading, banking, applying for loans, including mortgages, obtaining insurance quotes or other information that requires personal information);

- Chat rooms; and

- Online retail or other purchasing.

If you or someone in your family uses **Instant Messaging (IM)**, understand that you pay a price for the convenience of this service: it's not private or protected. Let your family know that if anyone wants to send an e-mail containing private information, that it's best to use a regular e-mail account and encrypt the message.

Chat rooms are another place where personal information can get out. **Online chats** provide an arena for a countless number of listeners.

Caution any IM or chat room users in your family to avoid sending any messages that contain private or personally sensitive information.

Resisting all forms of online commerce is the safest way to go...but probably an impractical one today. If you cannot resist purchasing online, consider using

online cash equivalents like PayPal instead of using a credit card.

OTHER POINTS OF ACCESS

There are two other vulnerable spots when it comes to your personal information: **online job boards** and **mortgages**.

If you use the major job boards, you should know that those who get access to résumés may also include people bent on identity theft and fraud. And corporate job sites, which are considered safe by many, may not be much safer. Don't forget to safeguard your most private information when filling out those online job forms and **posting your résumé**.

Create a résumé you use for online posting, and one for person-to-person contact. When you create your "e-résumé," be as vague as possible. Avoid using your SSN, date of birth, full name of current employers, past employers or their actual titles.

You can still get a potential employer interested in you without revealing too much personal information.

Mortgage applications, like résumés, can also contain the raw materials for opening false accounts and obtaining fake identity cards. Few documents contain as much personal information as a loan application—names, addresses, phone numbers, birth dates, SSNs, bank account records, employment histories and per-

haps tax return information. If you just refinanced your home and you read in the paper that your mortgage firm was robbed of its computers, you have something to worry about.

> Mortgage firms, banks, brokerages, utilities, merchants and others all hold sensitive personal information. While businesses try to safeguard this data, it's impossible to plug all leaks.

So, as a consumer concerned about the information these companies hold, don't be afraid to ask about how they make sure those documents are secure and won't end up in the wrong hand. Work with an established, trusted company. **Don't work with a start-up boutique mortgage firm** you know nothing about.

TELEMARKETING FRAUD

We've all been haggled into staying on the phone longer than necessary to say "No" to a telemarketer, even a legitimate one. But ID theft schemes have also come through crafty telemarketers who not only get you to stay on the phone longer than you want, but they manage to get you to say "Yes" and pass over private information. You might be giving them the information freely just because you're sick and tired of being on the phone and you don't know how to hang up.

When you're fed up with a telemarketer on the other end of the line, **never hesitate to hang up**—right in

the middle of their pitch. Take extra precaution when dealing with a telemarketer with the following characteristics:

- High-pressure sales tactics.

- Insistence on an immediate decision.

- The offer sounds **too good to be true**.

- A request for your credit card number for any purpose other than to make a purchase.

- An offer to send someone to your home or office to pick up the money, or some other method such as overnight mail to get your funds more quickly.

- A statement that something is "free," followed by a requirement that you pay for something.

- An investment that is "without risk."

- Unwillingness to provide written information or references (such as a bank or names of satisfied customers in your area) that you can contact.

- A suggestion that you should make a purchase or investment on the basis of "trust."

- Unwillingness to provide a phone number or legitimate business address.

Never allow yourself to be bullied into a hurried decision. When in doubt, hang up! To avoid junk mail and telemarketing calls, you can **write to direct marketing associations** and request that your name be

removed from any junk mail lists. Be aware that almost every time you call an 800, 888 or 900 number, your name and address are captured by the company you dialed. This information becomes part of your **electronic profile**.

PDAs AND OTHER ELECTRONIC DEVICES

The world has gone wireless and that means convenience on one level, and a security nightmare on another.

- Wireless technology can quickly connect computers and broadcast every bit of transmitted information in the meanwhile to anyone with a computer and a $40 wireless networking card. So, a man with a hand-held PDA can walk down a busy street in Manhattan and **tap into your computer** four floors up a nearby building, or while you're drinking a latté in the nearby coffee shop, working on your laptop.

- There are dozens of ways to use these wireless programs on wireless hardware to snatch someone else's Internet access, IDs, passwords…and peep into the private affairs of individuals and businesses.

Because wireless technology relies on radio signals, a walk-by hacker can reach not only an intended target, but any compatible equipment **within a several-hundred-foot radius**.

You want to safeguard the information you store on any hand-held device—your Palm Pilot, BlackBerry, PocketPC and the like—from hackers, loss or theft. Products are finally emerging on the market that safeguard such information, as PDAs are being loaded with increasingly sensitive information—patient records, contact lists, price sheets, financial records and other proprietary information. These applications work on a wide range of devices with multiple layers of security. Users must enter a password to access encrypted data. If you try several times and fail to log on within a given time, the device will dump its files.

Any safeguards loaded onto a PDA cannot be turned off by an individual user. Hewlett-Packard, for example, is preparing a series of iPaq PDAs with a built-in fingerprint scanner and wireless LAN support that will make its PDAs more secure than earlier versions. Tips for users of wireless technology or PDAs:

- **Avoid using a wireless network** when in close proximity to insecure areas where strangers can access your data; this could be in parks, arenas, airports, offices, street corners, coffeehouses, public transportation or any heavily-trafficked public area.

- Think about limiting your wireless network to home use (unless you have curious neighbors!)

- Consider purchasing **applications for your PDA** that will safeguard the information you carry on it.

- Do your homework before making any purchases; don't sacrifice personal security for dollars.

DAILY DEALINGS

Protecting your identity is a daily practice. Shred mail that contains your information, and that is headed for the trash can. Re-evaluate **how many credit cards you need** and consolidate them down to as few as possible. If you have any that you don't use, which have open lines of credit, get rid of them.

It's time to **organize your records** and financial matters. Keep your critical documents (deeds, titles, insurance papers, Social Security card, health information, military discharge documents, mortgage documents, investment documents, etc.) in one place and secure. Think about using a safety deposit box or at least a fireproof box at home to store the information safely.

> Don't give away private information at events that gather lots of people, strangers included (e.g., weddings, large parties, awards ceremonies, holiday gatherings, graduations, etc.) You'd be surprised by the number of unscrupulous people who like to hang out at such events (or work them).

Pay attention to opportunities for people to take advantage of your information. Reduce your chances of becoming a victim by **thinking ahead** and making plans accordingly. If, for example, you plan to hit the town and go on a pub crawl with your friends until 4 A.M., leave your wallet at home and carry only one form of ID (a license) and cash. Avoid carrying credit cards that you'll leave, among other important things, in a bar, taxi cab or the middle of the street.

CONCLUSION

Think about your privacy every day. You make multiple transactions every day and allow access to your personal information unknowingly more than you'd like to think. This chapter gave you some of the lifestyle changes you need to make to secure your personal identity. None of these changes can guarantee that your identity is safe from abuse. But combined, these practices will give you a suit of armor that might **deflect a potential thief** to another, more vulnerable person.

Coming up, you'll learn how to survive a stolen identity once it has occurred. There's a lot you can do to avoid a stolen ID, but there's more to do once it has happened and you have to clean up the mess. In Chapter 10, you'll read about dealing with government agencies, law enforcement, the credit bureaus, credit card companies, banks, DMV, etc. Dealing with an ID theft is a tough and long process. And it's best to know what to do *before* it happens. *Just in case….*

HOW TO SURVIVE
YOUR STOLEN ID

You know how to prevent an ID theft from occurring—or at least lower your risk of ID theft. But nothing can guarantee that it won't happen to you, so knowing how to deal with a theft once it has occurred is important. It could be a simple theft of someone joyriding with your credit card or it could be a serious theft involving thousands of dollars, drugs, crime, violence and perhaps terrorists.

You may not even know how the criminal got your information. Worry less about the point of entry when you discover a problem, and focus your attention on **cleaning up the mess**. In this chapter, you'll get step-by-step advice for what to do the moment you realize someone is impersonating you.

Credit card companies are making so much money that they encourage banks to give out accounts, mail cards to everybody and give cards away in malls. They assume that consumers will accept the fraud as the cost of doing business. They don't really look at the cost to the actual victim, you.

> According to one PIRG study, the average identity theft victim spends over two years and at least $800 out of pocket, trying to recover from ID theft.

STEP ONE: GET ON THE PHONE

Contact the fraud department at each of the major three credit bureaus. Inform them of the basis of your concern and **ask them to "flag" your file**. A flagged file means creditors will have to get your approval before any new account is opened in your name or a change is made to an account.

> Confirm your conversation in writing by sending a letter to each credit bureau stating whom you spoke to, when, what was discussed and any promises of follow-up action made by you.

Be clear in your letters about the specific outcome you want, whether it's a deletion or a correction. Include a copy of the credit report with the disputed item(s) circled or highlighted, as well as a factual explanation for why you're disputing each item.

If you're questioning a debt listing, include in your letter a request for copies of any proof that you owe the debt, such as a **signed contract or registered note**. List the account number and, if possible, include copies of bills and/or payment stubs that prove you're in the right.

Make copies of your letters and send copies; keep originals. Send letters via registered or certified mail with return receipt requested. Keep a **log of your conversations** and retain copies of all correspondence.

Obtain a copy of your credit report from each of the three credit bureaus. (See pages 185-186 in Chapter 8 for this information.) Review each report for peculiar activity; close any account that has been opened in your name that you did not authorize. When you place a fraud alert on your record, ask each credit bureau how long the flag will remain on your file—and when you'd need to renew it. Each bureau works differently. The hotlines for each bureau are:

- **Equifax's** (*www.equifax.com*) **hotline**: (800) 525-6285.

- **Experian's** (*www.experian.com*) **hotline**: (888) 397-3742.

- **TransUnion's** (*www.tuc.com*) **hotline**: (800) 680-7289; fax: (714) 447-6034.

Contact creditors for accounts that have been tarnished or opened fraudulently. Speak to the security or fraud investigations department, and follow-up every phone call with a letter in writing.

You may also want to make a **notarized affidavit of fraud**. This is simply a letter that you write—describing the dates, types and amounts of bogus charges—and have notarized as coming from you. A notarized affidavit of fraud can be used effectively in most legal proceedings—if such proceedings do happen.

Close compromised accounts and **stop payment**, if necessary. Use different personal identification numbers (PINs) and passwords to open new accounts.

Notify your bank(s) of the theft. Cancel your checking and savings accounts, and open new ones with **new numbers and passwords**, etc. Obtain new ATM cards with new passwords. Ask the bank to issue you a secret password that must be used in every transaction. Put stop payments out on any outstanding checks that you are unsure of.

Report stolen checks and fraudulent bank activity to Telecheck and the National Processing Company (NPC). These companies will flag your file so that bogus checks will be turned down. Call Telecheck at (800) 366-2425. Call NPC at (800) 526-5380.

Notify the Social Security Administration's Office of the Inspector General if your Social Security number has been used fraudulently.

General Number of SSA: (800) 772-1213.
SSA Fraud Hotline, P.O. Box 17768,
Baltimore MD 21235.
Fax: (410) 597-0118
Call: (800) 269-0271
TTY: (866) 501-2101

If your number has become associated with bad checks and credit, you may want to have your number changed…but this should only be considered during extreme situations. You must notify all credit grantors and credit reporting bureaus of your new SSN. A **new SSN may not resolve your identity theft problems**, and may actually create new problems. For example, a new SSN does not necessarily ensure a new credit record because credit bureaus may combine the credit records from your old SSN with those from your new SSN. Even when the old credit information is not associated with your new SSN, the absence of any credit history under your new SSN may make it more difficult for you to get credit. There's no guarantee that a new SSN wouldn't also be misused by an identity thief.

Other places to call:

- Notify the Passport Office to be on the lookout for anyone ordering a new passport fraudulently (877) 4USA-PPT; 1-877-487-2778; TDD/TTY: 1-888-874-7793);

- Call your telephone, electric, gas and water companies and warn them that someone might attempt to open new service using your identification;

- File a **complaint with the police** where the theft took place;

- File a complaint with the U.S. Postal Service if personal mail was stolen (see Chapter 11);

- If your identity was used to get a driver's license, visit your local DMV office to get a new license number. Also, if your state uses your SSN as your driver's license number, ask to substitute another number; and

- Contact the FTC to file a complaint. Fill out an online ID theft complaint (at *www.consumer.gov/idtheft*), or call the ID theft hotline at (877) ID-THEFT (438-4338). You can also do this by mail: Identity Theft Clearinghouse, Federal Trade Commission, 600 Pennsylvania Avenue, NW, Washington, D.C. 20580.

- Seek **legal council** if you have a problem getting creditors or credit reporting agencies to remove fraudulent entries. The FTC offers a sample dispute letter on its Web site. Disputes may require a sworn statement and a police report. For a form affidavit that can be used for the sworn statement, go to *www.consumer.gov/idtheft/affidavit.htm*.

If a thief has established new phone or wireless service in your name and is making unauthorized calls that appear to come from—and are billed to—your cellular phone, or is using your calling card and PIN, contact your service provider immediately to cancel the account and calling card. Get new accounts and new PINs.

KEEPING A PAPER TRAIL

Keep copies of all complaints, letters and correspondence. Maintain meticulous logs of your conversa-

tions and correspondence, including dates and names. When you file the police report, don't forget to get a copy of that, too. Your creditors might ask for that as **proof of the crime**.

> Be polite but persistent when pursuing the clean-up. Discuss your situation with trusted friends and perhaps seek the advice and support from a counselor or victim rights organization. Contacting your local Consumer Credit Counseling Service office might expedite removal of fraudulent claims from your credit report. Call (800) 388-2227 for a list of offices.

Make sure you get copies of all documentation from all three major credit bureaus. Why? Because even though the three bureaus are similar, they will not have identical information. That's why you should buy one report from each instead of paying $30-plus for a merged or combination report of all three.

> Merged credit reports are harder to read than the individual ones. The real estate industry is the only one that uses a merged report, so if you have to dispute an item or items on your report, you'll want the individual ones.

You'll need an individual report if you plan to dispute a listed item.

IF LOCAL LAW ENFORCEMENT FAILS

One of the hardest parts to dealing with identity theft is getting anyone to **help you quickly**. Calling the credit bureaus, your bank and creditors won't fix the problem immediately. It's like getting into a car accident. Even if the accident wasn't your fault, once you file the claim with your insurance company, it usually takes months—years, even—to get results. You won't see a resolution in 24 hours or a check in your name at the end of the day. And you won't get "pain and suffering" damages when all is said and done.

Because the laws regarding identity theft lack definition and the nature of the crime requires a multi-jurisdictional collaboration, you might find it challenging to get local law enforcement to do anything effectively.

> You'll need a police report to dispute unauthorized charges and for any insurance claims. Your police department may say this is unnecessary (they usually do because they don't want the paperwork). *Always* fill out a police report as soon as you have proof of bogus credit card charges or other evidence of ID theft.

Although the Secret Service has jurisdiction over financial fraud cases, it's hard for an individual to get the federal agency's attention unless the dollar amount is significant. If you want their attention, ask someone in the fraud department of your credit card companies and/or banks to notify the particular Secret Service agent with whom they work.

THE WAITING GAME

Waiting for results can be tiring. Once you've disputed an item on your credit report, the law says the credit agencies have **30 days to respond** whether or not the disputed item is correct. If you don't get any response within that time frame, then all disputed items must be removed. Most likely you'll hear from the credit bureau within those 30 days.

> **The bureaus' replies should include a new copy of your credit report and a cover letter explaining the results of its investigation into your disputed item(s). Disputed items will often be listed as "verified no change," "deleted" or the report will contain some updated information.**

Deletions are good since those items will no longer haunt your credit. Updated information is also good, since these are usually corrected names, addresses or other possible late-status info.

Verified items are still part of your file. If you still think the item is wrong, try **contacting the original creditor** who placed the listing.

If the report says an item is "unverified," then by law it must be removed from your file. Send a copy of this along with a letter requesting the unverified item be deleted. The credit bureau must make the change you requested and notify anyone who received a credit report containing that unverified item.

By the way, sometimes items are later verified and put back on your file. Just remember that items cannot be reinserted on your report unless the credit bureau **notifies you in writing.**

If a reinvestigation doesn't eliminate a disputed item, you can file a **statement of up to 100 words** explaining your side of the story. Credit bureaus must include this explanation in your report any time they send it out.

CREDIT REPAIR SERVICE

If you've got an extreme case of identity theft and you can't get the credit bureaus to remove the disputed items from your report, you might have to resort to a credit repair service for more help.

> Beware: Use credit repair shops with caution. Many will falsely guarantee things or make too-good-to-be-true statements. Credit repair shops cannot guarantee to clean your record…but they can guarantee to raise your credit score.

Adding insult to injury, some ID thieves set up bogus credit repair operations as a pretext for getting ID information of inattentive people. To avoid the **scam artist** working in the credit repair shop, consider these tips:

- Look around for repair shops that are established and offer reasonable rates that aren't dirt cheap or ridiculously expensive.

- Check with the Better Business Bureau or local Chamber of Commerce to get histories and accreditations.

- Before you hire a credit repair service, read their contracts carefully and ask about refunds.

Typically, a credit repair service will cost you $500. This may seem like a lot of money, but it might be a good investment if it cleans up errors and allows you to apply for lower-interest loans and lines of credit. If you do go with a credit repair service, you should not apply for credit until the company's work is completed. And, again, don't expect a perfect ending.

> Remember: Whether you fight the battle yourself or get professional help, you can wipe out errors from your credit report. Disputing wrong information is just one of the many ways you can take control of your financial future.

One of the most common things a shady credit repair company will do is bombard the credit reporting companies with disputes about items on an individual's credit report with the hope that the credit reporting companies will be too overwhelmed to confirm all items within 30 days, and will then temporarily remove negative items from the consumer's credit report. This won't fix your report in the long run, since any verified item will come back.

Another thing to watch out for: credit repair shops that encourage you to create a "new" credit report or

identity by applying for an **employer identification number** to use instead of your Social Security number. Obtaining an EIN, which is used primarily by businesses, under false pretenses is a crime. If you're fighting an identity theft case, the last thing you want is to do something illegal in cleaning up after someone else's criminal behavior.

CREDIT WATCH SERVICES

We talked about all the new services offered by credit card companies, credit bureaus and insurance companies to monitor your credit. Although most of these services can cost—upwards of $120 a year—it might be worth it for you to have, especially if you don't know whether the person who has already stolen your identity once won't do it again.

> Credit watch services won't do much that you can't do on your own. What these services offer is a helping hand through the credit bureaucracy. The FTC will take a report of the identity theft, notify law-enforcement officials and offer advice, but it won't resolve the problems a thief leaves behind.

If you didn't have insurance to help cover the expense incurred by fixing an ID theft problem, consider getting some. Call your **homeowners or renters insurance company** to inquire about adding a rider or purchasing a stand alone policy. But be careful: you might already have some coverage on your policy. And, you should not have to pay more for the security you should already be getting automatically

from your credit bureaus and credit card companies. Maybe it's time to **evaluate the kinds of cards you carry** in your wallet, and the kind of service you get when you call those toll-free numbers for help.

When battling the credit card agencies to erase credit they gave out to someone impersonating you, request a "letter of clearance" that you can use to send to collection agencies. And when you do, send it certified mail, return receipt requested, and keep a copy for your files.

DON'T FORGET THE LAWS

Starting in Chapter 6 we took a look at the laws and agencies that are available to help you when you become a victim of identity theft. Don't forget about your **rights and options**. Federal laws mandate procedures for correcting credit report and billing errors and for stopping debt collectors from dunning you for sums you do not owe. The **Truth in Lending Act** limits your liability for unauthorized credit card charges to $50 per card in most cases. The Fair Credit Billing Act establishes procedures for resolving billing errors on your credit card accounts, including fraudulent charges.

If someone steals your checks and forges your signature, there are no federal statutes that limit your losses, but state laws offer some protection. Most states hold the **bank responsible for losses** from a forged check—provided that you have taken reasonable care

of your account and you notify the bank promptly that a check was lost or stolen

The Fair Credit Reporting Act establishes procedures for correcting mistakes on your credit records and requires that access to your records be limited to people who have a permissible purpose.

> **Remember: If you file a claim with a credit bureau stating that your records are inaccurate, the credit bureau must investigate it in a timely manner, usually within 30 days. It must delete from your file any disputed information that cannot be verified and must also correct erroneous information.**

Even though the law gives you important protections and rights, the old proverb still holds: An ounce of prevention is worth a pound of cure.

FIGHTING BACK

One summer day, Jerad Rose, from Louisville, Kentucky, bought computer equipment from an online merchant. Three days later, while checking his bank statement online, he discovered an unauthorized purchase for $825. Rose immediately paid a visit to his bank and canceled his card. But it was too late. Within a few days, 14 purchases, totaling more than $1,600, had been charged to his account. Rose had broken one of the most important online rules: **he'd used his debit card**. So the criminal had access to his bank account, leaving his checking account overdrawn.

Rather than let his bank handle the matter, Rose called each of the online merchants where illegal purchases were made and explained his problem. Together, Rose and the vendors were able to **trace the computer** from which the order came, confirming that it wasn't from his computer. The result? He prevented more than $1,100 in sophisticated camera equipment from being shipped to an unknown person in Indonesia.

Rose's experience—and his persistence in getting to the bottom of his problem—is a lesson to all: You must become a savvy, aggressive consumer and take matters into your own hands. While it's important to get your identity mess cleared up, it's also important and useful to get an explanation as to when, where and how the fraud occurred.

Jill Maggio's experience is yet another example of what fighting back can do. One day, a man entered her San Jose cellular shop and asked for four phones for his business. He showed Maggio his company Web site and, after clearing his credit check, he paid the $719 bill with a company check.

But the company wasn't his…and the check was counterfeit. Maggio didn't simply pick up the phone and notify police or cancel the man's Nextel's service, however. Instead, she got crafty and had the man's **voicemail service rerouted** to her. She recorded his messages and sometimes spoke with his callers. When she had enough ammo (i.e., people the police could actually contact), she turned it all over to the San Jose

police. After 20 years in the business, Maggio wasn't about to let her first counterfeit scam go unpunished.

Authorities eventually arrested the man responsible, Julian Antonio Torres of San Mateo. He was part of a Bay Area crime ring that stole mail from posh homes in San Francisco, Woodside and elsewhere, then used the credit cards and bank accounts to buy luxury hotel rooms, fancy sports cars, motorcycles, laptops and other electronic gadgets.

SOFTWARE FOR VICTIMS

Alongside the growing ID theft problem is an expanding market for products that help consumers manage the clean-up process. Identity Restoration, Inc., for example, has introduced a software program—IDentity SecurityNet—that helps victims repair their damaged names and prevent future damage.

> Such programs can walk you through the process of clearing your name and credit by organizing and tracking vital information.

User-friendly computer programs that guide you through the difficult process of completing letters and forms, providing a complete report for law enforcement, and taking measures to prevent theft can **help remove some of the frustration** out of damage control. Particularly useful of these programs is their ability to link you to the places you need to go: the Social Security Administration, law enforcement agencies, credit card companies, credit reporting agencies,

banks and financial institutions…and various government agencies. Further, you can access Web sites that answer questions about privacy and personal security.

A note about services and programs: There's nothing wrong with paying someone to help you navigate the clean-up process once your identity has been stolen. But **know what your limits are** for shoveling money out for expensive programs, access to 24-hour ID theft hotlines and credit watches. The great majority of ID theft prevention and management (i.e., clean-up) is free. For example, it doesn't cost money to notify the credit card companies and Social Security Administration of your theft…but you could pay someone to help you do that.

> Cleaning up the leftover mess from an ID theft will cost you in time, energy, postage (for the letters you send) and perhaps the help of an attorney in dire situations (e.g., you've been arrested falsely and need to get out of jail). What you decide to spend on extra help getting back on track is up to you.

Keeping alert is one of the most important things to do post-theft. The problems often don't end with phone calls and follow-up letters—particularly if the thief is still at large and still using your identity. For some, paying for a service or program that keeps you tuned in to the ongoing problem is worth the money.

CONCLUSION

Besides the frustration you must endure once your identity has been stolen and abused, there's a lot to be said about the other emotions that accompany the crime: anger, **embarrassment and disbelief**. You cannot keep the issue a secret or think that it will take care of itself in a short time. Identity theft often affects the people around you, too—your friends, your family and even your business colleagues.

Falling victim to any crime is life-changing. It's not an experience anyone should go through alone. Talk to your family, friends and business contacts about your problem and what you are doing to fix it. It might make you feel better knowing there are people to support you. They will most likely want to help in some way, which they can do by simply watching out for you and **keeping your head up**.

When someone runs off with your ID, don't sit and ponder where you went wrong or where you goofed and let a thief walk into your shoes. Focus, instead, on the problem. Once you make those initial phone calls to the Feds, police, credit agencies and bureaus, call your friends and family to let them know. There's nothing to be embarrassed about. As this book has shown, **ID thieves don't discriminate**. They fool stupid people as well as sharp people; they can dupe a young, old, rich or poor person. ID theft can happen to anybody.

In the next and final chapter, you'll find a checklist of things to do before, during and after someone has stolen your identity. These are good checklists to have when you need a quick refresher course on this complex and deepening problem.

11

CHECKLISTS &
CONTACTS

The following chapter is a **collection of checklists** to refer to when dealing with identity theft. Some of this information was adapted from the FTC's Web site at *www.ftc.gov*, which is a great source of information, links and advice. The site contains sample dispute letters and an affidavit you should fill out when you suspect someone has illegally used your ID. Remember: Identity theft often involves crimes committed across state lines and requires multi-jurisdictional cooperation. You'll have to contact many places in the clean-up process.

VICTIM'S OVERALL GOALS

- Close fraudulent accounts;

- Clear yourself of responsibility for any debts or other criminal activities the thief has perpetrated in your name;

- Ensure that your credit report is correct; and

- Find out as much information about the suspect as you can so you can share that information with the police and the FTC.

ORGANIZATION

Start with phone calls, but follow each and every call with a letter in writing. Use certified mail, return receipt requested.

- Keep **copies of all correspondence** or forms you send. Send copies, keep originals.

- Log every phone call with names, numbers, details of the conversation, what you were told, and the date of the conversation. Consider **setting up a folder** on your computer to handle the logging of information. You can use a spreadsheet or a word processor—unless you have already purchased a program that simplifies the process—to organize the information in a quickly retrievable manner.

- Set up a **filing system** for easy access to your paperwork.

- **Keep old files** even if you think your case is closed. Although most cases once resolved, stay resolved, in some cases, problems can crop up again. Should this happen, you'll be glad you kept your files.

IMMEDIATE CALLS TO MAKE

- Call the toll-free fraud number of any one of the three major credit bureaus to **place a fraud alert** on your credit re-

port. This can help prevent an identity thief from opening additional accounts in your name.

- When you receive your reports, review them carefully to make sure no fraudulent accounts have been opened in your name or unauthorized changes made to your existing accounts.

- **Contact the creditors** (for example, credit card companies, phone companies and other utilities and banks and other lenders) to close any accounts that have been tampered with or opened fraudulently. Ask to speak with someone in the security or fraud department of each creditor. It's particularly important to notify credit card companies **in writing**.

- File a report with your local police. Get a **copy of the police report** in case the creditors, credit bureaus or others need proof of the crime.

- File a complaint with the FTC.

COMPUTER PROTECTIONS

The World Wide Web opens many doors, both for you to the outside world, and for others looking to come into your home via your home computer. As much as a personal tool the Web can be, it can also be a key for others to use to access your personal information. Take action to help **safeguard your personal computer** from myriad things: damage or misap-

propriation of your software and data; viruses; objectionable content; intruders contacting your children, etc. There's a lot to protect when it comes to your computer and several things you can do to minimize unwelcome consequences to your privacy and computer security. Because a lot of ID theft is perpetuated by computers and the Internet, securing your computer is key. To **assess your risks**, ask yourself:

- What is your computer used for?

- Who has **access to your computer**?

- What kind of Internet connection service do you have? (cable? DSL?)

- How often is your computer online as opposed to offline?

- What sort of **security features** do you have on your computer? Firewall? Content advisor settings? Anti-viral software?

- What kind of sites are your users visiting when on the Web?

- What kinds of transactions are taking place on your home computer?

- What are your **children** doing on the Internet? Do they have unsupervised access?

WHEN MAKING ONLINE PURCHASES

- Check **seals of approval** links to verify merchants' authenticity (e.g., TrustE, BBBOnline, BizRate, etc.);

- Call companies on the phone to judge their legitimacy;

- **Read privacy policies**;

- Verify electronic security protocols;

- Know what a merchant will do with your personal information;

- Know how to tell when a transactions gets encrypted (i.e., before you enter a credit card or personal information, look for "https" instead of "http" in the address bar and for the lock icon at the bottom of your browser; and

- Check you monthly statements for transactions that don't look familiar.

THE RED FLAGS

Mail: Your mailbox—filled with incoming or outgoing mail—is an easy target. Watch out for missing bills or bank statements. Check washing is another method; a thief can wash out the ink on a signed check, change the amount and rewrite the check to himself. Watch out for those pre-approved credit cards that come in the mail, too.

Fraudulent change of address: A thief can fill out a change-of-address form at the post office or with the victim's credit card company so the mail and bills get redirected to the thief's address or mail drop.

Trash cans and dumpsters: Business and building dumpsters are attractive items to thieves looking for discarded letters with business and customer account information. A thief can disguise himself as a homeless person digging through garbage.

Onlookers: Whenever you expose your ATM or calling card in a public place, someone might be looking. They might even look from afar with the help of binoculars, camcorders or a zooming camera.

Lost or stolen purse or wallet: This is when keeping certain things like your Social Security card and health insurance card (which often bears your SSN) out of your purse is key.

Inside jobs: An employee of a business might illegally retrieve information that a business has collected for legitimate reasons. An entry-level employee at a financial institution, for example, might be able to access others' personal information, and sell it to identity thieves.

Internet: Personal Web pages are targets, and genealogical databases give thieves access to maiden names, which are often used as passwords to bank accounts and the like.

Skimmers: Thieves who carry skimmers, devices that can read the magnetized strip from a credit card, bank card for account numbers, balances, verification codes,

are hard to spot because they often work where you're using your card to make purchases. These thieves obtain temporary work within restaurants, hotels and retail stores where they capture and retain the information from the card you hand over when making a purchase.

Pretexting: You might be duped into giving up your personal information over the phone with someone who disguises himself as a representative with a reliable company that you use, like your phone company, local department store or cable company.

SIMPLE PREVENTIVE MEASURES

- **Ask your employer** to dispose of sensitive, personal information and to secure anything that cannot be destroyed.

- Ask your employer to control access to sensitive, personal information...and to limit the use of your Social Security number in the workplace.

- **Buy a personal shredder** and use it to shred bank and credit card statements, canceled checks and pre-approved offers before throwing away.

- **Secure your mailbox** with a locking mechanism or use a door with a mail slot.

- Avoid leaving outgoing checks or paid bills in your residential mailbox. Take all mail to the post office or nearest U.S. Mailbox. Consider paying bills electronically.

- Check your credit report annually with Experian, TransUnion or Equifax and look for address changes and fraudulent accounts.

- **Pick up re-ordered checks** at your bank instead of having them mailed to you.

- Notify your credit card company if your card has expired and you have not yet received a replacement.

- **Clean your wallet** out of excess information. Do not carry your Social Security card.

- Check your bills carefully. Look for discrepancies between your receipts and statements. Open bills promptly and report anything unchecked quickly.

- When making purchases with a credit card in public, keep your eyes on your card, try to keep the numbers facing down, and get it back as soon as possible.

- Keep a **record of your credit card information** in a safe place.

- Limit amount of information on the Internet, including your home page or Web sites that detail family genealogy.

- Don't give out personal information over the phone unless you initiated the call and know who you are calling.

THE BIG THREE CREDIT BUREAUS

Equifax: *www.equifax.com*

- To order your report, call: (800) 685-1111 or write: P.O. Box 740241, Atlanta, GA 30374-0241.

- To report fraud, call: (800) 525-6285 and write: P.O. Box 740241, Atlanta, GA 30374-0241.

- Hearing impaired call (800) 255-0056 and ask the operator to call the Auto Disclosure Line at 1-800-685-1111 to request a copy of your report.

Experian: *www.experian.com*

- To order your report, call: (888) EXPERIAN (397-3742) or write: P.O. Box 2002, Allen TX 75013.

- To report fraud, call: (888) EXPERIAN (397-3742) and write: P.O. Box 9530, Allen TX 75013; TDD: 1-800-972-0322.

TransUnion: *www.transunion.com*

- To order your report, call: (800) 888-4213 or write: P.O. Box 1000, Chester, PA 19022.

- To report fraud, call: (800) 680-7289 and write: Fraud Victim Assistance Division, P.O. Box 6790, Fullerton, CA 92634; TDD: 1-877-553-7803.

OTHER TIPS

- Seek **legal council** if you have a problem getting creditors or credit reporting agencies to remove fraudulent entries.

- Use different personal identification numbers (PINs) and passwords to open a new accounts.

- Obtain new ATM cards with new passwords. Ask the bank to issue you a secret password that must be used in every transaction. Put **stop payments** out on any outstanding checks that you are unsure of.

- Report stolen checks and fraudulent bank activity to Telecheck and National Processing Company (NPC). These companies will flag your file so that bogus checks will be turned down. Call TeleCheck: (800) 710-9898 or 927-0188. Call NPC at (800) 526-5380. Call Certegy, Inc. (previously Equifax Check Systems) at (800) 437-5120.

- To find out if the identity thief has been passing bad checks in your name, call: SCAN: (800) 262-7771

- Notify the Social Security Administration's Office of the Inspector General if your Social Security number has been used fraudulently. If your number has become associated with bad checks and credit, you may want to have your number changed…but this should only be considered during extreme situations. You

must notify all credit grantors and credit reporting bureaus of your new SSN.

- Notify the **Passport Office** to be on the lookout for anyone ordering a new passport fraudulently.

- Call your telephone, electric, gas and water companies and warn them that someone might attempt to open new service using your identification (see below).

- File a complaint with the U.S. Postal Service if personal mail was stolen (see below).

- Be polite but persistent when pursuing the clean-up. Discuss your situation with trusted friends and perhaps seek the advice and support from a counselor or victim rights organization.

- Contacting your local **Consumer Credit Counseling Service** office might expedite removal of fraudulent claims from your credit report. Call (800) 388-2227.

If you're having trouble getting your financial institution to help you resolve your banking-related identity theft problems, including problems with bank-issued credit cards, contact the agency with the appropriate jurisdiction. If you're not sure which of the agencies listed below has jurisdiction over your institution, call your bank or visit *www.ffiec.gov/nic.htm* and click on "Institution Search."

THE FDIC

The Federal Deposit Insurance Corporation (FDIC) at *www.fdic.gov* supervises state-chartered banks that are not members of the Federal Reserve System and insures deposits at banks and **savings and loans**.

Call the FDIC Consumer Call Center at (800) 934-3342; or write: Federal Deposit Insurance Corporation, Division of Compliance and Consumer Affairs, 550 17th Street, NW, Washington, D.C. 20429.

FEDERAL RESERVE

The Federal Reserve System (Fed) at *www.federalreserve.gov* supervises state-chartered banks that are members of the Federal Reserve System.

Call: (202) 452-3693; or write: Division of Consumer and Community Affairs, Mail Stop 801, Federal Reserve Board, Washington, D.C. 20551; or contact the Federal Reserve Bank in your area. The 12 Reserve Banks are located in Boston, New York, Philadelphia, Cleveland, Richmond, Atlanta, Chicago, St. Louis, Minneapolis, Kansas City, Dallas and San Francisco.

THE NCUA

The National Credit Union Administration (NCUA) at *www.ncua.gov* charters and supervises **federal credit unions** and insures deposits at federal credit unions and many state credit unions.

Call: (703) 518-6360; or write: Compliance Officer, National Credit Union Administration, 1775 Duke Street, Alexandria, VA 22314.

THE OCC

The Office of the Comptroller of the Currency (OCC) at *www.occ.treas.gov* charters and supervises **national banks**. If the word "national" appears in the name of a bank, or the initials "N.A." follow its name, the OCC oversees its operations.

Call: (800) 613-6743 (business days 9:00 A.M. to 4:00 P.M. CST); fax: (713) 336-4301; write: Customer Assistance Group, 1301 McKinney Street, Suite 3710, Houston, TX 77010.

THE OTS

The Office of Thrift Supervision (OTS) at *www.ots.treas.gov* is the primary regulator of all federal, and many state-chartered, **thrift institutions**, which include savings banks and savings and loan institutions.

Call: (202) 906-6000; or write: Office of Thrift Supervision, 1700 G Street, NW, Washington, D.C. 20552.

MAIL FRAUD

- The **U.S. Postal Inspection Service** (USPIS) is the law enforcement arm of the U.S. Postal Service and is responsible for investigating cases of identity theft.

- USPIS has primary jurisdiction in all matters infringing on the integrity of the U.S. mail.

- If an identity thief has stolen your mail to get new credit cards, bank or credit

card statements, pre-screened credit of-
fers or tax information, has falsified
change-of-address forms, or obtained
your personal information through a
fraud conducted by mail, report it to your
local postal inspector.

- You can locate the USPIS district office
nearest you by calling your local post of-
fice or checking the list at *www.usps.gov/
websites/depart/inspect*.

BANKRUPTCY FRAUD

If you believe someone has filed for bankruptcy in
your name, write to the **U.S. Trustee (UST)** in the
region where the bankruptcy was filed.

A list of the U.S. Trustee Programs' Regional Offices
is available on the UST Web site, or check the Blue
Pages of your phone book under "U.S. Government
Bankruptcy Administration."

For more information, visit the Web site at
www.usdoj.gov/ust

INVESTMENT FRAUD

The **U.S. Securities and Exchange Commission's
(SEC) Office of Investor Education and Assis-
tance** serves investors who complain to the SEC
about investment fraud or the mishandling of their
investments by securities professionals.

Additional investment fraud tips:

- If you believe that an identity thief has tampered with your securities investments or a brokerage account, immediately report it to your broker or account manager and to the SEC.

- You can file a complaint with the SEC using the online complaint center at: *www.sec.gov/complaint.shtml*.

- Be sure to include as much detail as possible. If you don't have access to the Internet, you can write to the SEC at: SEC Office of Investor Education and Assistance, 450 Fifth Street, NW, Washington D.C., 20549-0213. For general questions, call (202) 942-7040. For general information: *www.sec.gov*.

PASSPORT FRAUD

If you've lost your passport or believe it was stolen, or is being used fraudulently, contact the **United States Department of State (USDS)** at *www.travel.state.gov/passport_services.html* or call a local USDS field office. Local field offices are listed in the Blue Pages of your telephone directory.

PHONE FRAUD

If an identity thief has established phone service in your name, is making unauthorized calls that seem to come from—and are billed to—your cellular phone,

or is using your calling card and PIN, contact your service provider immediately to cancel the account and/or calling card. Other phone fraud tips:

- Open new accounts and choose new PINs. If you're having trouble getting fraudulent phone charges removed from your account or getting an unauthorized account closed, contact the appropriate agency from the list below.

- For local service, contact your state **Public Utility Commission**, listed in the Blue Pages of your telephone directory.

- For cellular phones and long distance, contact the Federal Communications Commission (FCC; *www.fcc.gov*). The FCC regulates interstate and international communications by radio, television, wire, satellite and cable.

- You can contact the FCC's Consumer Information Bureau to find out about information, forms, applications and current issues before the FCC. Call: (888) CALL-FCC; TTY: (888) TELL-FCC; or write: Federal Communications Commission, Consumer Information Bureau, 445 12th Street, SW, Room 5A863, Washington, D.C. 20554.

- You can file complaints via the online complaint form at *www.fcc.gov/cgb/complaints.html*, or e-mail questions to fccinfo@fcc.gov.

STUDENT LOAN FRAUD

Contact the school or program that opened the student loan to close the loan. At the same time, report the fraudulent loan to the **U.S. Department of Education**.

- Call: Inspector General's Hotline at (800) MIS-USED

- Online: *www.ed.gov/offices/OIG/hotline.htm*

- Write: Office of Inspector General; U.S. Department of Education; 400 Maryland Avenue, SW; Washington, D.C. 20202-1510

TAX FRAUD

The **Internal Revenue Service (IRS)** (*www.treas.gov/irs/ci*) is responsible for administering and enforcing tax laws.

If you believe someone has assumed your identity to file federal Income Tax Returns, or to commit other tax fraud, call toll-free: (800) 829-0433.

Victims of identity theft who are having trouble filing their returns should call the IRS Taxpayer Advocates Office, toll-free: (877) 777-4778.

SSN THEFT AND MISUSE

The SSA's Office of the Inspector General investigates cases that involve the use of your SSN to fraudulently obtain Social Security benefits.

The SSA Office also investigate cases that involve the use of counterfeit SSN cards, the manufacturing or selling of counterfeit SSN cards, the selling of legitimate SSN cards or information, or the misuse of SSNs linked to terrorist groups or activities. Tips for SSN abuse:

- Report any of these allegations to the SSA Fraud Hotline. Call: (800) 269-0271; fax: (410) 597-0118; write: SSA Fraud Hotline, P.O. Box 17768, Baltimore, MD 21235; or e-mail: oig.hotline@ssa.gov.

- You also can call SSA at (800) 772-1213 to verify the accuracy of the earnings reported on your SSN, and to request a copy of your Social Security Statement or to get a replacement SSN card if yours is lost or stolen. Follow up in writing.

- For more information, visit their Web site at *www.ssa.gov/pubs/idtheft.htm*

ATM FRAUD

The **Electronic Fund Transfer Act** provides consumer protections for transactions involving an ATM or debit card or other electronic way to debit or credit an account. It also limits your liability for unauthorized electronic fund transfers. Other tips include:

- Report lost or stolen ATM and debit cards immediately because the amount you can be held responsible for depends on how quickly you report the loss.

- If you report your ATM card lost or stolen within two business days of discovering the loss or theft, your losses are limited to $50.

- If you report your ATM card lost or stolen after two business days, but within 60 days after a statement showing an unauthorized electronic fund transfer, you can be liable for up to $500 of what a thief withdraws.

- If you wait **more than 60 days**, you could lose all the money that was taken from your account after the end of the 60 days and before you report your card missing.

- The best way to protect yourself in the event of an error or fraudulent transaction is to call the financial institution and follow up in writing by certified letter, return receipt requested.

After receiving notification about an error on your statement, the institution generally has **10 business days** to investigate. The financial institution must tell you the results of its investigation within three business days after completing the investigation and must correct an error within one business day after determining that the error has occurred. If the institution needs more time, it may take up to 45 days to complete the investigation—but only if the money in dispute is returned to your account and you are notified promptly of the credit. At the end of the investigation, if no error has been found, the institution may take the money back if it sends you a written explanation.

- VISA and MasterCard have voluntarily agreed to **limit consumers' liability** for unauthorized use of their debit cards in most instances to $50 per card, no matter how much time has elapsed since the discovery of the loss or theft of the card.

CRIMINAL VIOLATIONS

If you are accused wrongfully of a crime, contact the arresting or citing law enforcement agency (i.e., the police or sheriff's department that originally arrested the person using your identity, or the court agency that issued the warrant for the arrest).

- File an **impersonation report** to confirm your identity. The police department may take a full set of your fingerprints and your photograph, and make copies of any photo identification documents like your driver's license, passport or visa. They should compare the prints and photographs with those of the imposter to establish your innocence.

- If the arrest warrant is from a state or county other than where you live, ask your local police department to send the impersonation report to the police department in the jurisdiction where the arrest warrant, traffic citation or criminal conviction originated.

The law enforcement agency should then recall any warrants and issue a **"clearance letter"** or certificate of release (if you were arrested/booked). Keep this document with you at all times in case you're wrongly arrested. Also, ask the law enforcement agency to file, with the district attorney's (D.A.) office and/or court where the crime took place, the record of the follow-up investigation establishing your innocence. This will result in an amended complaint being issued. Once your name is recorded in a criminal database, it's unlikely that it will be completely removed from the official record. Ask that the "key name," or **"primary name,"** be changed from your name to the imposter's name (or to "John Doe" if the imposter's true identity is not known), with your name noted only as an alias. Other things to do:

- To clear your name in the court records, you'll need to determine which state law(s) will help you do this and how. If your state has no formal procedure for clearing your record, contact the D.A.'s office in the county where the case was originally prosecuted. Ask the D.A.'s office for the appropriate court records needed to clear your name.

- Finally, **contact your state DMV** to find out if your driver's license is being used by someone else. Ask that your files be flagged for possible fraud.

- If you think your name or SSN is being used by an identity thief to get a driver's license or a non-driver's ID, contact your DMV. If your state uses your SSN as your driver's license number, ask to substitute another number.

LINKS TO STATE AND LOCAL GOVERNMENT

National Conference of State Legislatures: *www.ncsl.org*

Alabama Attorney General: *www.ago.state.al.us*

Alaska Attorney General: *www.law.state.ak.us*

Arizona Attorney General: *www.attorneygeneral.state.az.us*

Phoenix Police Department: *www.ci.phoenix.az.us/PO-LICE/idthef1.html*

Arkansas Attorney General: *www.ag.state.ar.us*

California Attorney General: *caag.state.ca.us*

California Office of Privacy Protection: *www.privacyprotection.ca.gov*

California Department of Motor Vehicles: *www.dmv.ca.gov*

Colorado Attorney General: *www.ago.state.co.us*

Connecticut Attorney General: *www.cslib.org/attygenl*

Delaware Attorney General: *www.state.de.us/attgen*

District of Columbia Office of the Corporation Counsel: *occ.dc.gov/main.shtm*

Florida Attorney General: *legal.firn.edu*

Georgia Attorney General: *ganet.org/ago*

Georgia Stop Identity Theft Network: *www.stopidentitytheft.org*

Hawaii Attorney General: *www.state.hi.us/ag/index.html*

Idaho Attorney General: *www2.state.id.us/ag*

Illinois Attorney General: *www.ag.state.il.us*

Indiana Attorney General: *www.in.gov*

Iowa Attorney General: *www.iowaattorneygeneral.org*

Kansas Attorney General: *www.accesskansas.org/ksag*

Kentucky Attorney General: *www.law.state.ky.us*

Louisiana Attorney General: *www.ag.state.la.us*

Maine Attorney General: *www.state.me.us/ag*

Maryland Attorney General: *www.oag.state.md.us*

Massachusetts Attorney General: *www.ago.state.ma.us*

Michigan Attorney General: *www.michigan.gov/ag*

Minnesota Attorney General: *www.ag.state.mn.us*

Mississippi Attorney General: *www.ago.state.ms.us*

Missouri Attorney General: *www.ago.state.mo.us*

Montana Attorney General: *doj.state.mt.us*

Nebraska Attorney General: *www.ago.state.ne.us*

Nevada Attorney General: *ag.state.nv.us*

New Hampshire Attorney General: *www.state.nh.us/nhdoj*

New Jersey Attorney General: *www.state.nj.us/lps*

New Mexico Attorney General: *www.ago.state.nm.us*

New York Attorney General: *www.oag.state.ny.us*

North Carolina Attorney General: *www.jus.state.nc.us*

North Dakota Attorney General: *www.ag.state.nd.us*

Ohio Attorney General: *www.ag.state.oh.us*

Oklahoma Attorney General: *www.oag.state.ok.us*

Oregon Attorney General: *www.doj.state.or.us*

Pennsylvania Attorney General: *www.attorneygeneral.gov*

Rhode Island Attorney General: *www.riag.state.ri.us*

South Carolina Attorney General: *www.scattorneygeneral.org*

South Dakota Attorney General: *www.state.sd.us*

Tennessee Attorney General: *www.attorneygeneral.state.tn.us*

Texas Attorney General: *www.oag.state.tx.us*

Utah Attorney General: *attorneygeneral.utah.gov*

Vermont Attorney General: *www.state.vt.us/atg*

Virginia Attorney General: *ww.oag.state.va.us*

Washington Attorney General: *www.wa.gov/ago*

West Virginia Attorney General: *www.state.wv.us/wvag*

Wisconsin Attorney General: *www.doj.state.wi.us*

Wyoming Attorney General: *attorneygeneral.state.wy.us*

INDEX